MARIA-CHRISTINA
SAYN-WITTGENSTEIN
NOTTEBOHM

OLD MASTERS ROCK

HOW TO LOOK AT ART WITH CHILDREN

PIMPERNEL
PRESS LTD
www.pimpernelpress.com

For Charles and Gaspar

In memory of Charles A. Ryskamp

www.pimpernelpress.com

*Old Masters Rock How to Look at Art
with Children*
© Pimpernel Press Limited 2016
Text © Maria-Christina Sayn-Wittgenstein
Nottebohm
Photographs © as per credits on page 112

A catalogue record for this book is available
from the British Library

Designed by Arianna Osti

Typeset in Stempel Garamond

ISBN 978-1-910258-040

Printed and bound in China

9 8 7 6 5 4 3 2 1

who
are you
in the
picture?

Did you
know?

PG13 are for works
of art which require
parental discretion

FUN FACTS

C lues

CONTENTS

THANKS

Warm thanks go to my husband Charles Nottebohm; Carmen de Piniés-Hassel, my 'other eye'; Otto Naumann and Elizabeth Boburg who have spent countless hours editing the entries and making brilliant suggestions.

Gaspar and his friends Anna de la Isla, Andrew Luhnow, Valerie Pera and Nicholas Pera have made wonderful observations and were the inspiration for this book.

I thank Gary Tinterow, director of the Museum of Fine Arts, Houston for his eloquent foreword and Philippe de Montebello, director emeritus, Metropolitan Museum of Art and Fiske Kimball Professor in the History and Culture of Museums at New York University's Institute of Fine Arts for his kind support.

I am immensely grateful to the private collectors for letting me include their pictures. I am indebted to the pre-eminent curators at the museums and distinguished scholars who have been generous with their time and help with the text.

My thanks also to the following: Colin B. Bailey, Joseph Baillo, Sylvain Bellenger, Dirk Blübaum, Jean Bonna, David Bull, Keith Christiansen, The Duke of Devonshire, Prince Jonathan Doria-Pamphilij, Isabelle Harnoncourt-Feigen, Richard L. Feigen, Susan Grace Galassi, Alain Goldrach, William M. Griswold, Gloria Groom, Charlotte Hale, The Landgrave of Hesse, Philip Hewat-Jaboor, Johann Kraeftner, the late Walter Liedtke, J. Patrice Marandel, Laure and Olivier Meslay, Mary Morton, Patrick Noon, Philippa Nuttall, Rose-Marie and Eijk van Otterloo, Cristóbal Pera, Renée Price, Sabine Rewald, Lord Rothschild, The Royal Collection Trust, Joseph J. Rishel, Prince zu Salm-Salm, Anna Sanderson, Scott J. Schaefer, Martin Schawe, George Shackelford, Dominique Surh, Vendeline von Bredow, Arthur K. Wheelock Jr., Alan Wintermute and Mrs. Charles Wrightsman.

> In the book I have used the term Old Masters to mean great artists from past centuries.

FOREWORD

About three years ago, Maria-Christina Sayn-Wittgenstein-Nottebohm (known as Puppa) sent me her first essays for *Old Masters Rock*. I was immediately enchanted. I had known for some time that her son and sidekick Gaspar was a confidant connoisseur and knowledgeable museum visitor, as he had already guided me through museums in New York and Mexico City. It was always a pleasure to see things through his eyes: he showed me unexpected details, asked questions that had never occurred to me, and inevitably focused on a central issue that I had ignored because I was too pre-occupied with movements, 'isms', and questions of attribution and condition. Gaspar always got to the point, sweeping away art-historical nonsense to arrive at an essential observation, often with an expression of qualitative judgment. He knew what he liked, he knew what was good, and often he could spot when something was wrong.

Taking a cue from Gaspar's Socratic method, Puppa wrote about her favourite paintings, bringing to the fore her own experience as an art dealer, adviser to collectors, and agent working with many of the leading curators in the United States and Europe. *Old Masters Rock* is in the best sense a collaborative effort, initiated by Gaspar's curiosity, sustained by Puppa's knowledge of art, and enriched by her many friends in the field. Needless to say, Gaspar would have written a different book, because his range of interests is far more extensive than that of his mother or her friends. But what they have created here is a delightful introduction to Old Master painting, demystifying art history in order to make iconic pictures accessible to adults who are justifiably turned off by professional jargon and academic approaches. Above all, Puppa provides the means to encourage children to trust their instincts, and gives parents the authority to listen to the wisdom of their children. If they do, a wonderful time will be had by all, and a lifetime of rewarding experiences will be initiated.

Gary Tinterow
Director, the Museum of Fine Arts Houston

LOOKING AT ART

Art detectives, it is time for you to take charge. Ask your parent or teacher to take note of the following tips and then read the book together.
I hope that what you discover will spark your interest in great art; there is so much to explore. Old Masters Rock!

There is no magic secret about how to look at art and there are no wrong or right answers – it is all about your own response to it. As you read this book you will become familiar with the type of questions that help us discover things about a work of art and how we feel about it. Whether you are an adult or a child, being curious is your starting point. Curiosity will reveal what interests you in a painting.

VIRTUAL VISIT

Not everyone can visit the great museums in person but luckily that should not stop you from enjoying art. The internet makes it possible to zoom in on the smallest details of a work of art. Visit the different museum websites and the Google Cultural Institute (www.google.com/culturalinstitute) where there are many high-resolution images. There are, of course, many books in libraries where you can explore artists and their work.

Whether you are visiting an actual museum or just looking at art online or in a book the key points are the same.

ART CAN BE FUN

'Let's look at art' can trigger shrieks of horror from kids but once you get into Old Masters, you (and they) may get hooked for life. When we visit a museum or art gallery we all make the same mistakes. We look by ourselves rather than together with our children and we try to cram everything in. However,

if you use this book as a tool you will discover that looking at art can be fun – whether it is in a book, on the internet or in a museum

VISITING A MUSEUM

If you are planning that once-in-a-lifetime trip to Paris, Rome, London or New York you may be be tempted to try and see *everything*. **Don't!** Your family will neither enjoy the trip nor remember much. If you want to avoid a 'nightmare at the museum' follow some key steps:

• Before you leave, explore the city and the museums online together with your child. Choose a handful of things that each of you want to focus on during the visit.

• Buy your tickets online. This is often cheaper and you will avoid the queues.

•Always do the child-friendly activity first and your thing in the afternoon. This is the only way to avoid the all-familiar mantra, 'can we go now?'.

• Forget the 'Mona Lisa' syndrome! Many pictures in the Louvre are more interesting than that particular Leonardo and the same applies to most major collections around the world. Don't just go for the blockbusters – they will be crowded and you will learn more by discovering other hidden gems.

•Read about what you want to see in advance. Print a child-friendly version of that Greek myth or historical event. If you are not prepared, you'll lose your audience zzzZ.

• Get a map at the information desk and let your child guide you through the museum. Some museums are very child-friendly. At the Cloisters, the Metropolitan Museum's superb medieval collection, they will give you a map that serves

> A small reward for focused behavior will serve as a memory of your visit. It can be as simple as a postcard of their favourite painting.

"On a trip to Rome, my then ten-year old son was in charge of reading the street map. This empowered him and I was thrilled to have a personal guide who led us through the Roman maze. We first visited the Colosseum and the Forum, places that he had been longing to see and then we saw the paintings galleries and churches. We had a blissful time walking through the Eternal City. After seven hours on our feet, that delicious pizza was well deserved!"

as a treasure hunt. The game is to spot the mythical animals throughout the collection.

• At a pinch, use the audio guides, however exploring together is infinitely more memorable and rewarding.

• Go with your kid's passions, even if you are more interested in seeing Impressionist pictures. You will be surprised at what you will learn from them.

• My husband always makes museum visits particularly fun. He will ask our son to find an animal or spot a gruesome battle scene. Children love treasure hunts; choose things your child is interested in and challenge him or her to find an example in a painting during the visit.

• Don't overdo it. Once you have seen a few things, leave or take a break. Always leave some room for impromptu decisions and let yourself be surprised. If my family manages to see four out of the seven things on our list, we are content.

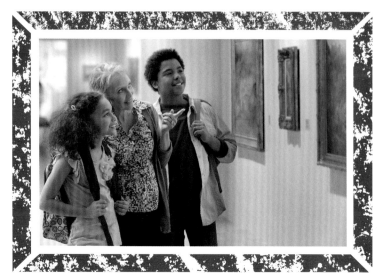

> Remember, you should never touch a painting as you may damage it.

"We were at the Philadelphia museum when our son was five. Entering the eighteenth century gallery he instantly identified a painting by George Stubbs, the great British animal painter. He had enjoyed looking at the animals in a book on Stubbs that we have at home. Identifying the original painting deepened his interest and made him proud."

HOW TO LOOK AT ART WITH CHILDREN

Whether you are in a museum or looking at art at home the most important thing you can both do is **ASK!** First, let your child look alone, and then ask some questions. As you read through this book you will become familiar with the type of questions to ask but some common ones might be:

➲ *What is the story?* Together with your child you can decode the symbols and stories. If you are not sure what's going on try and figure it out together. These paintings were done at a period when most people could not read or write so the artist is using the picture to tell a story.

➲ Don't overload your child with dates and facts. It is more fun to work things out visually (and it helps us remember them). Focus on getting visually involved with the picture instead.

➲ *Do you think that portrait of the king or other ruler is about demonstrating his power or revealing his human side?*

➲ *What do you think the sitter in the portrait was like as a person?*

⮱ *What time of the day is it? What is the weather like?*

⮱*Was the picture painted in the studio or* en plein air *(outside)*? Don't worry if you are not sure – what do you *think* by looking at the picture?

⮱*Who would you like to be if you were one of the figures in the picture?*

⮱ *Spot and name any animals you can see!*

Always look for a particular element which will help you to remember the picture.

Ask your child to assume a role in the painting so they can actually 'enter' the scene in their imagination. Encourage them to tell a story about what they are seeing.

Who would you choose to be in the picture?

Kids like to think about how things are made. The label will tell you something but the picture tells you more: look at it closely and see whether the paint is crusty and heavy or perhaps you can see the canvas or paper through it. Look and you will discover!

Spot the under- drawing!

⮱ *Is it a drawing on paper or oil on canvas?* How can you tell?

⮱After reading this book, visit a museum or website. Ask your child to find a painting by Vermeer for example or another artist in the book. You will be surprised at their immediate expertise.

SURPRISE

Looking at art with my son and his friends has been a revelation for me. You will be amazed at how sharp kids are, how quickly they grasp the artist's message and at their fascinating observations. You will start out hoping that you will teach your child about art but in the end it will be the reverse: your child will be teaching you!

ART IS COOL, ART IS FUN. OLD MASTERS ROCK!

THE SMILING PIGLET

Why is this piglet smiling? Could it be saying: "just you wait until I grow up"?
When it is grown up this charming piglet will turn into a huge, scary beast called a wild boar. This pig is highly intelligent. It is able to live anywhere and eats anything!

➲ Look at the eyes, ears and snout. What do you think is the boar's most developed sense?

Do you think Hoffmann kept the piglet as a pet so he could paint it?

FUN FACTS

● A wild boar can smell humans from 11km (6.8 miles) away.
● The snout has a hard disk at the end and works like a bulldozer.
● A boar can sniff out food up to 8 metres (26 feet) underground.
● Although the pig can hear well it cannot see much.
● Check your hairbrush! It may be made with wild boar bristles.
● Historically, hunting wild boar was the sport of kings.

PORTRAIT OF A PIG
First Hoffman drew the outline of the pig on the prepared vellum (parchment). Then he defined the muscles and bones. He had to wait for each brushstroke to dry before applying the next. ➲ Look carefully and you will see every single bristle, the rough ones on top of the soft ones. *Do you think it took a long time to paint the pig?*

A MAGICAL CASTLE
Emperor Rudolf II (1552–1612) asked Hoffmann to work for him in Prague, Bohemia (now Czech Republic). Prague castle was the centre of the Imperial court of the Holy Roman Empire. It was a bustling place filled with leading philosophers, scientists, magicians and even exotic animals. Alchemists were experimenting with making the fabled 'Philosopher's Stone', said to turn cheap metal into gold (see page 88). Rudolf was more interested in magic than in ruling his empire. The castle must have been a creepy place, dimly lit by candles and torches during the dark Bohemian winters. You never knew whom might you run into in the long, spooky corridors, perhaps even the Emperor himself.

HOFFMANN

<u>Hans Hoffmann</u> was born in Germany c.1530. Not much is known about his training but he probably travelled before settling in Nuremberg. Hoffmann's monogram *Hh* is easy to spot. He wants us to see the world his way: beauty can be found everywhere. A squirrel, a cat and a hedgehog can be as amazing as a lion. Hoffman liked painting natural subjects and he admired Albrecht Dürer (1471–1528), who painted the famous *Hare* (Albertina, Vienna) 78 years earlier. Hoffmann gave his animals more human expressions than Dürer's.

Signed with monogram and dated Hh1578

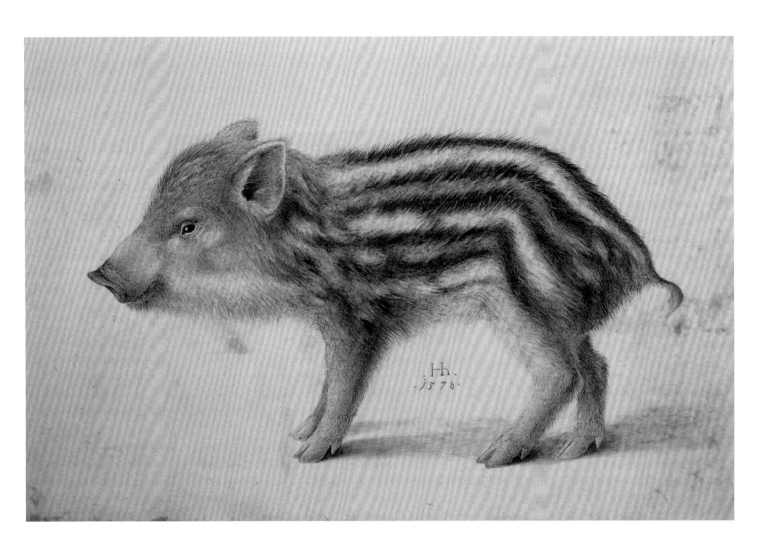

Hans Hoffmann (German, 1545/50–1591/2)
A Wild Boar Piglet, 1578
Water-based opaque and transparent paints with traces of metal point under-drawing
Vellum prepared with a lead ground, 30 × 45.5cm (12 × 18½in)
Collection Jean Bonna, Geneva

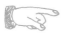 **Gustave Courbet (French, 1819–77)**
Fox in the Snow, 1860
Oil on canvas, 85.7 × 128cm (33¾ × 50¾in)
The Dallas Museum of Art, Texas

FOX IN THE SNOW

It is winter and windy and cold in the mountains. The fox has been stalking his prey. He watches, listens and jumps high to pounce. *What animal did he catch?* Can you see the bloodstains in the snow? The fox has just landed on the mouse and his back is still arched. *Do you think it is easy for a fox to find food during the freezing winter months? What time of the day do you think it is?*

What do you think of this picture? Do you find the subject matter cruel? Courbet is showing us the reality of nature and the food chain. **Foxes are part of that food chain too.** Humans have been hunting foxes for centuries. In the past, people commonly wore their beautiful fur as coats.

FUN FACTS

- The red fox is long, light and fast and a high jumper. He could easily jump over an adult's head. A dog of the same size is much heavier than a fox.
- Red foxes live alone or in family groups in the northern hemisphere. The red fox does not hibernate in winter. When it gets cold the fox's fur grows thick. The winter coat with the bushy tail keeps him warm so he can sleep in the wild without shelter. How many different shades can you see in the fur?
- The fox's pupils are vertical so he can hunt at dusk. The fox has a highly developed sense of hearing. Scientists now believe that the fox uses the magnetic field of the earth to locate the distance to his prey when he hears it but cannot see it.
- It is difficult to tell a vixen (female) from a dog (male). The dogs are a bit bigger than the vixens.

COURBET

Courbet enjoyed hunting in the countryside near his native Ornans in eastern France. He knew the anatomy of animals. He never depicted a cute furry fox playing with his cubs. That would be too sentimental for his taste. He was a Realist painter and in *Fox in the Snow* we witness the reality of animal life.

This was a period of turmoil and unrest and Courbet's political activities landed him in jail in Paris. His sisters visited him in prison and took him flowers and fruit. He used these to paint some beautiful still lifes during his time in jail.

HOW HE DID IT

Courbet designed his pictures directly onto the canvas. His way of painting was a bit wild. As if he were the fox, he pounced on the canvas with a loaded palette knife. In some areas he spread the paint around with the knife. He used a finer paintbrush for the more delicate brushwork. ➜ *Can you identify the areas where he uses the knife and the brush?*

SUBJECTS

Courbet's favourite subjects were things like huge, waves, funerals, realistic hunting scenes and men at work. He painted flesh and blood women rather than making them look like **porcelain dolls**.

Signed lower left:
Gustave Courbet

LET SLEEPING DOGS LIE

The dog has curled up on a wooden ledge next to various objects. He doesn't seem afraid that anything will fall on him. It is impossible to tell if it is a female or a male dog. The dog's topcoat is rough and the undercoat is smooth. Dou takes care to paint every hair of the topcoat. Everything has a different texture. The dog's eye and nose are shiny; *what does that tell you?* Shiny eyes and nose are a sign that a dog is healthy.

Do you think it is a puppy or an old dog?

Are we inside a hut or outdoors?

Imagine you are sitting so close you could pet the dog. You can feel the yellow velvety moss on the twigs. Do you have a bundle of sticks in your home? *What do you think the sticks are for?* If you were to run your fingers along the wicker tray you may get a splinter.

ART DETECTIVES

Can you guess who his master is? Is it an adult or a child? ➲ **Clue:** Look for the shoes. The shoes are small simple wooden clogs rather than fancy shoes that a rich person would wear.

What else can you find on the ledge? There are sticks for a fire, a water jug and a tray.

What condition are the items in? Everything seems a bit broken: the lid of the pot is missing a big chunk and the edges of the basket are frayed. The clogs are a bit chipped at the heels. The dog is in great shape though. He is well fed and his wiry coat is well groomed. He clearly is his master's prized possession.

Where does the light come from? Is it is daylight or candlelight? Perhaps a ray of early morning light is shining through a crack. The dog has opened one

watchful eye! *What name would you give the dog?* ➲ You can find the same dog in a painting by Gerrit Dou in the Alte Pinakothek in Munich, *The Prayer of the Spinner*. Perhaps the dog was Dou's own?

BRUSHWORK

Dou's brushwork was so fine that he made his own paintbrushes. His pictures are unusually small and it took him many hours to complete a single work. Compare the way Dou applies paint to Rembrandt (see page 78) and Hals (see page 42) and Vermeer (see page 70). They were all painting at the same time. *How are they different?*

DOU

Dou was born in Leiden in the Netherlands. He studied with Rembrandt (see page 78) but then developed his own style. It was a period called the Golden Age of Dutch painting. Dou loved fine details and surfaces. He preferred to paint small pictures on panel. He is what is called a *Fijnschilder*, a 'Fine Painter': one of a group of artists from Leiden who liked to paint small, detailed realistic pictures. Like Caravaggio (see page 82), Dou was also interested in chiaroscuro, the sharp contrasts of light and dark.

Signed and dated lower center: G. DOU 1650

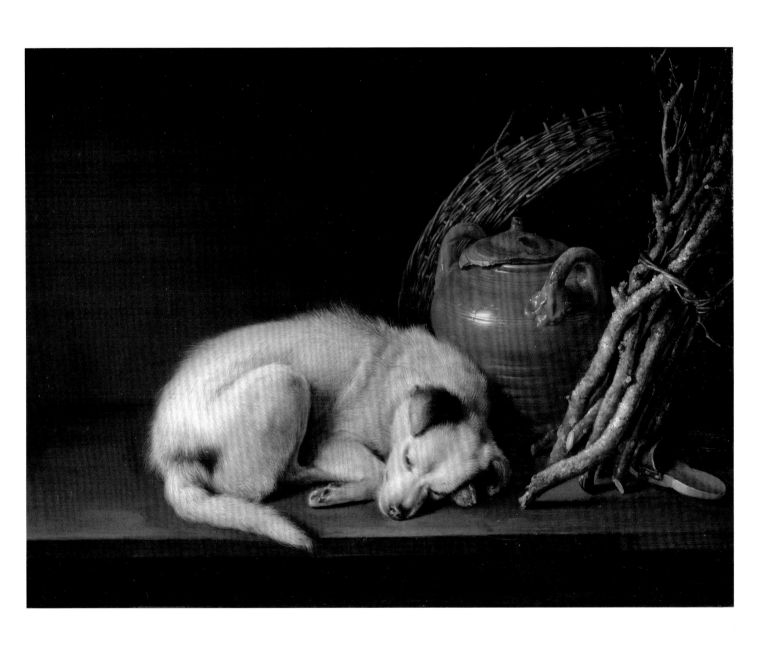

Gerrit Dou (Dutch, 1613–75)
Sleeping Dog, 1650
Oil on panel, 16.5 × 21.6cm (6½ × 8½in)
Rose-Marie and Eijk van Otterloo Collection

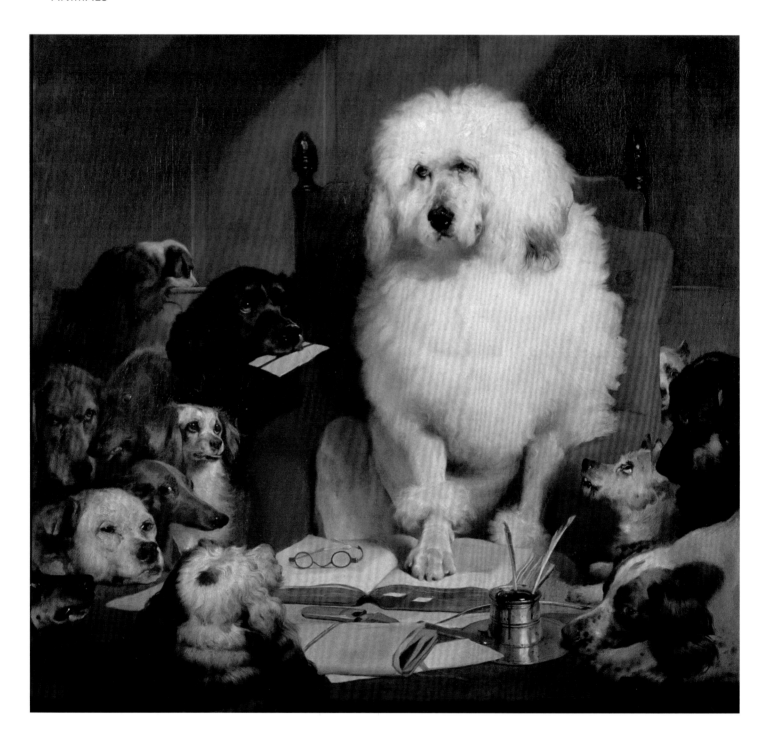

 Sir Edwin Landseer (British, 1802–73)
Laying Down the Law, 1840
Oil on canvas, 72 × 95cm (28¼ × 37½in)
Devonshire Collection, Chatsworth

LAYING DOWN THE LAW

'Quiet please. The court is in session!' You are in a court of law – *or are you?* What is unusual about this London courtroom? The judge is a puffy French poodle! You must respectfully address him as 'My Lord'.

A British judge wears a white wig and a red robe trimmed with ermine.

Does this poodle resemble a judge in full court dress?

What can you find on his lordship's desk? ➲ Spot some documents, quill pens, an inkwell and a stick of sealing wax.

The judge has put down his glasses and is looking very serious. His paw is pointing to the law book. The clerk, who is a black retriever, is giving him a document. Could that be the verdict?

TRIAL BY JURY

Approach the bench please. The judge is about to discover the jurors' decision!

In a trial by jury twelve jurors – ordinary people – decide whether the accused is guilty or not. Meet the jurors: find a greyhound, a deerhound, bloodhound, two spaniels, various terriers and a mastiff!

The dogs exhibit human emotions. Identify which dogs are bored, focused, annoyed, calm, distracted or gentle? *What is grabbing the spaniel's attention behind the bench?*

How would you describe the character of the judge? *Is he puffed up and pompous or is he intelligent and full of dignity?* Would you describe the greyhound as a snob? Perhaps he thinks he is above the others?

THE INSPIRATION

Landseer was with a friend in London when they saw a man and his dog. The friend was a judge and told Landseer that the French poodle looked exactly like the Lord Chancellor. The poodle's master was a well-known dandy. A dandy is someone with exquisite manners who is primarily concerned with his appearance. *Do you think is a dandy is deep thinker and reads books? Does our judge look like a dandy?* Landseer returned to his studio and began the painting.

How many dogs can you see? Originally there were twelve jury-dogs plus the judge in the painting. However, when the Duke of Devonshire bought the painting, he asked Landseer to squeeze in his favourite **Blenheim Spaniel**, Bony. ➲ You will find Bony peeking out behind the black greyhound on the left. He has long brown ears and a white face.

FUN FACTS

A French poodle is a water dog with webbed feet. He is an intelligent working dog, bred to retrieve birds from lakes and rivers. His lower body is shorn so the wet fur does not weigh him down and swimming is easier. The top hair is left long to keep him warm. The puffy cuff at the ankle keeps the poodle from getting rheumatism.

LANDSEER

Landseer was the most famous animal painter of his time. He lived during the reign of Queen Victoria (1819–1901). The Queen loved her animals and Landseer's work was a favourite. In London's Trafalgar Square you can see four huge bronze lions made by Landseer. When Landseer died flags were flown at half-mast and he was buried in St Paul's Cathedral, London.

PET ERMINE

Is this young woman smiling? *Why is she looking over her shoulder instead of looking at us?* Where is the light coming from? *Could she be looking out of an open window?* How old do you think she is? Meet sixteen-year-old Cecilia, the girlfriend of the Duke of Milan.

CECILIA

Her tight, long braid is held in place by a cap made of transparent gauze. *Can you tell the colour of her hair?* The border of the cap is embroidered with gold thread and positioned so it sits above her eyebrows. A thin black ribbon is tied around her forehead. *What are the colours of her dress?* ➲ See the black ribbons on the bodice and sleeves that match the necklace?

What do you think the black beads are made of?

FUN FACTS

- Ermine are great at catching mice.
- Their summer coats are brown. In winter they turn white with a black-tipped tail.
- Ermine fur is traditionally used for royal robes (see Fouquet page 80).
- The background was originally greyish-blue. It was supposedly painted black by Eugene Delacroix in the nineteenth century.

THE ERMINE

This ermine is snuggling his long body around the lady's waist, almost like a belt. *Why do you think the fur turns from brown to white? Is the ermine in this picture wearing his winter or his summer coat?*
➲ This is a trick question, as the surface of the picture has discoloured over the centuries. The ermine's coat was originally white.

Leonardo is using the ermine to send a message. People used to say that an ermine would rather die than dirty its coat. Leonardo's hidden message is that Cecilia would remain faithful to her lover.

HOW WAS IT MADE?

Leonardo prepared the wood panel with white gesso. He drew an outline of the figure on paper. He transferred the drawing to the panel by first pricking small holes along the marks of the drawing. Then, laying the drawing over the panel, he pounced or dabbed the holes with a cloth bag of charcoal, creating a dotted outline of the drawing. Leonardo then connected the dots with either a brush or a silver point before applying paint. He used his fingers and the palm of his hand to smooth the transitions between the shadowed and the lit parts of her face. Under magnification one can see Leonardo's fingerprints. When the paint dried, the fingerprints remained.

Some experts think that he painted the ermine with his left hand.

WOMEN OF MYSTERY

Have a look at the *Mona Lisa* (The Louvre, Paris). Is the *Lady with an Ermine* as mysterious? What similarities and differnces can you find between them?

LEONARDO

Leonardo was a wizard! He was brilliant and loved science as well as painting, sculpture and drawing. He imagined many machines including flying machines. His secret notes were written in 'mirror-writing', with the letters in the reverse. Have you ever tried writing secret letters?

There are four beautiful paintings of women by Leonardo. *Lady with an Ermine* can be seen in Poland, two are in the Louvre and one is in the National Gallery in Washington. Each picture has its own mysterious and magical charm.

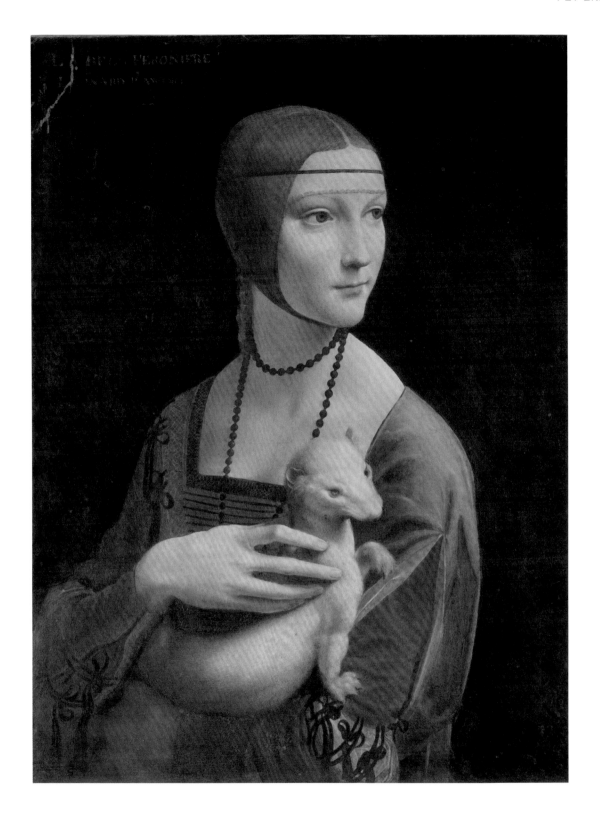

Leonardo da Vinci (Italian, 1452–1519)
Lady with an Ermine, c.1490
Oil on panel
54 × 39cm (21¼ × 15¼in)
Czartoryski Museum, Kraków

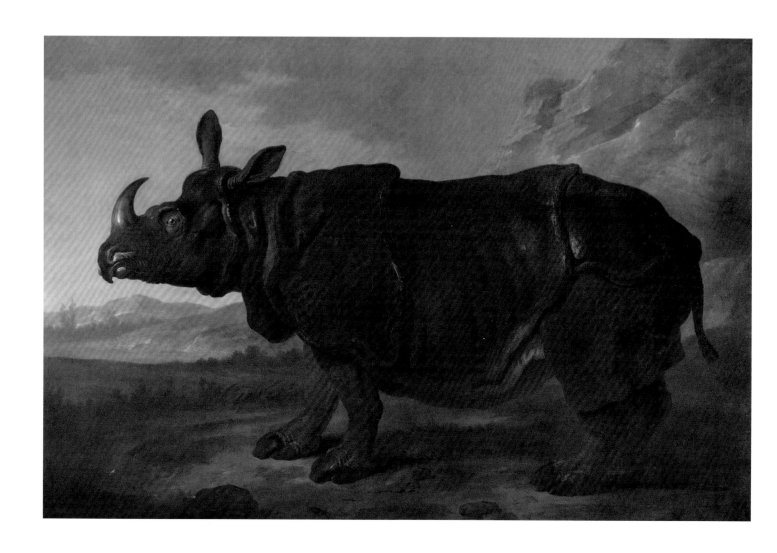

 Jean-Baptiste Oudry (French, 1686–1755)
Clara The Rhinoceros
Oil on canvas, 310 × 456cm (122 × 179½in)
Staatliches Museum, Schwerin, Germany

MISS CLARA

Those eyes, that nose, those lovely stubby legs! This irresistible young lady weighs about 2300kg (5000lbs). What's not to love?

Who is this beauty? Her name is Clara the Rhinoceros and she was born in India in 1738. She was one month old when her parents died and a man called Jan took her home and kept her as a pet. She ate from porcelain plates at the table and was allowed into all the rooms until she grew up and became too big to live in the house. Although **huge**, Clara was sweet tempered and not dangerous at all. A Dutchman took her on his ship to his native country, the Netherlands.

Clara was always hungry and she loved to feast on hay, oranges and beer!

What would you whisper in Clara's ear?

CLARA-MANIA

Very few people in Europe had ever seen a rhinoceros, so the Dutchman took her on tour. Soon Clara was the most popular young lady in Europe. There were Clara clocks, coins and prints and there was even a porcelain Clara, all shiny and smooth. People wrote poems and songs about her. The fashionable ladies in Paris were obsessed with Clara and wore wigs and ribbons in their hair à la rhinoceros. King Louis XV invited Clara to the palace of Versailles. She stayed in the king's menagerie for five months.

CLARA AND YOU

Clara is watching you and listening carefully. *What do you want to whisper in her ear? Doesn't she look intelligent. Do you want to stroke her nose and feel the folds of her skin? Would you like to have a pet rhino? Perhaps you could draw Clara instead.*

LOST AND FOUND

Clara's portrait was lost for 150 years. One hundred years after being painted, the canvas was rolled up and stored in the basement of a castle in Germany. It remained there until a few years ago. Museum curators discovered a roll of fabric hidden in the basement. When they unrolled it, they were surprised to discover that it was Clara's portrait, a bit battered but still gorgeous. They sent the canvas to the Getty Museum in California to be repaired. You can visit the museum in Schwerin, Germany, where Clara now presides in all her glory over a menagerie of other exotic animals.

PAINTING CLARA

Oudry painted Clara life-size. Four pieces of fabrics were sewn together to make a huge canvas. He prepared the background by painting a layer of deep red, and then he coated the canvas in a beige ground – that is, painting the whole surface. Oudry then outlined Clara's round form in thin oil paint. After that he built up several layers of paint and glazes. Finally he added some finishing touches, such as the fluffy wisps of hair around her ears.

FUN FACTS

- Rhinos cannot see very well but they have excellent hearing.
- Clara weighed the equivalent of a minibus.
- Rhinos in captivity sometimes rub off their horns. No one knows what happened to Clara's horn after her death.

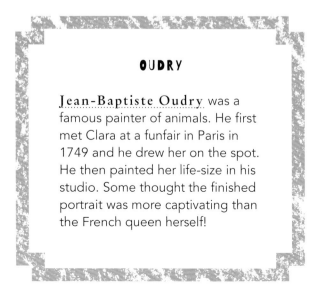

OUDRY

Jean-Baptiste Oudry was a famous painter of animals. He first met Clara at a funfair in Paris in 1749 and he drew her on the spot. He then painted her life-size in his studio. Some thought the finished portrait was more captivating than the French queen herself!

BROTHER SUN AND SISTER MOON

The man in the painting is an Italian called Francis. He was born about 300 years before Bellini painted this picture. Francis gave up his comfortable life, left his father and French mother and retreated to a life of prayer and poverty.

Francis loved animals and nature. He called them his brothers and sisters. Some said he could talk to animals. Imagine being Francis: your only clothing is a scratchy wood tunic with a cord belt. Your few possessions are listed below. *Can you spot them?*

Francis' father nicknamed him 'Francesco', the Frenchman.

• Red book resting on the wooden desk
• Skull (a reminder that we are mortals)
• Water jug
• Pair of wooden sandals

Francis once fasted for forty days and nights for Lent with only the animals to keep him company. *What do you think that would have been like?* After his death Francis was made a saint. He is known as **Saint Francis of Assisi.**

THE GARDEN

The green rocks have lots of plants and flowers growing in the cracks. Francis is barefoot – do the rocks look smooth enough for walking barefoot? The small herb garden has healing plants. ➜ *Can you spot 'Brother rabbit'?* Francis gets his water at the waterspout. Can you find it? **Hint:** find the red-bellied kingfisher.

HOME

A gate blocks the doorway. The roof above the entrance is covered with grapevines. The bell cord is a reminder for prayer rather than a call to come to lunch. Spot the simple cross with the Crown of Thorns. 'Brother donkey' and 'Sister crane' are nearby. Can you see the shepherd tending his flock near the town? A big laurel tree is bending in the wind. Warm rays of light are shining on to Francis, casting long shadows. What time of day do you think it is?

THE MOMENT

What is happening to Francis? Bellini painted him as he steps out of his hut to pray, his arms are stretched out, his eyes lifted up to the sky. *What do you think Francis might be feeling at this moment?*

FUN FACT

Bellini used expensive materials from different parts of the world in this picture. The blue pigment of the sky is made from lapis lazuli, a blue stone then mined in Afghanistan. It would have travelled all the way to Venice along the 'Silk Road', the trade route that brought goods from Asia to Europe.

BELLINI

<u>Bellini</u> lived in Venice, Italy and he came from a family of painters. He was one of the first Italians to use oil paint. Earlier artists used tempera – pigment mixed with a medium such as egg yolk. For this painting Bellini would have planned out his design in black paint on the prepared poplar panel before applying the coloured oil paint on top.

To see this painting at the Frick Collection in New York you have to be 10 years old and over.

Signed lower left on the paper
IOANNUS BELLINUS

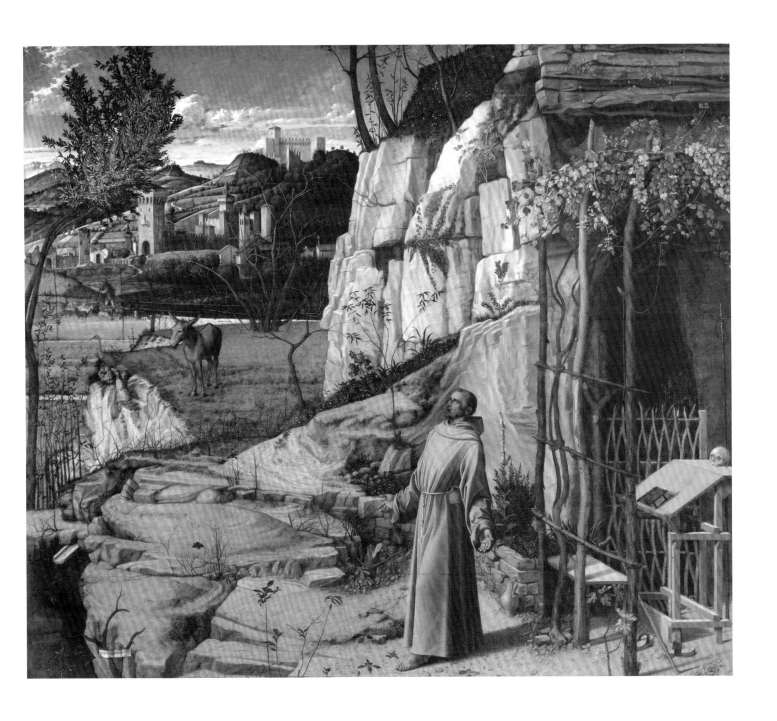

Giovanni Bellini (Italian, *c.*1430/1435–1516)

*St Francis in the Desert, c.*1475–78
Oil on poplar panel
124.6 × 142cm (49 × 56in)
The Frick Collection, New York

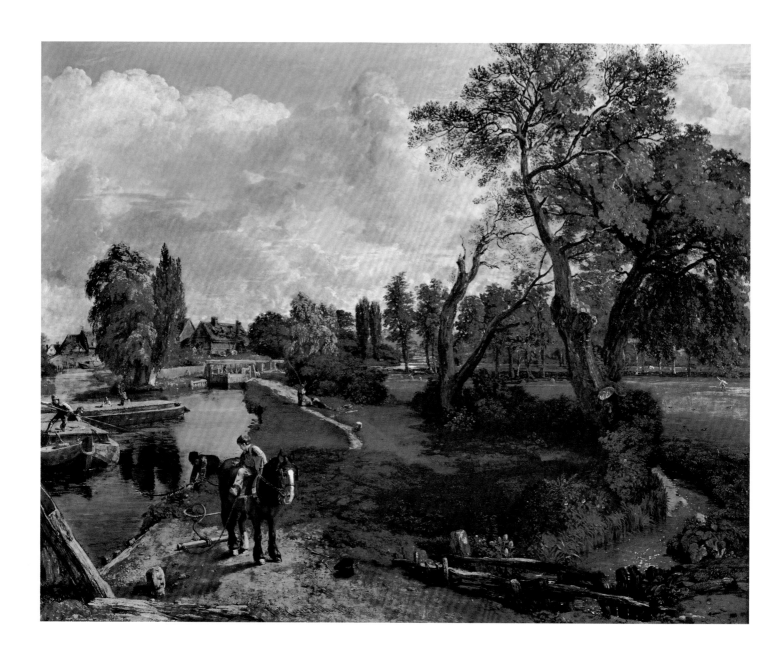

 John Constable (British, 1776–1837)
Flatford Mill (Scene on a Navigable River), 1817
Oil on canvas, 101.6 × 127cm (40 × 50in)
Tate Britain, London

A **SU**MMER JOB

It is late summer in the English countryside. Farmers have brought their wheat to the water mill. The water of the River Stour turns the wheel of the mill. The millstones grind or mill the wheat into flour. Barges transport the sacks of flour along the river to the English Channel. From there they sail south to join the River Thames westward to London. At the London food markets, people buy the flour to make bread and cakes.

A SUMMER JOB

What job would you like to do? Do you want to move the barges along the water with a pole? The Stour had been made navigable so barges could pass along the canal without running into obstacles like big rocks. In order to pull a barge you would need a good strong draft horse. The rope needs to be untied so the barge can pass under the footbridge.
➡ Spot the corner of the bridge!

If you sat next to Constable on the bank he would explain that he wants to feel and see everything around him. *Do you think he would see all those different shades of greens if he were to paint the picture inside his studio in London?*

ART DETECTIVES

Can you read the word that was scratched in the earth with a stick? It reads 'Jon Constable'. He painted the picture in the open air directly from nature.

CLOUD-SPOTTING

Constable studied **clouds** for hours on end. Clouds move quickly, so Constable had to paint fast. Meteorologists say Constable's clouds are always painted accurately. There are ten different types of clouds that are grouped into high clouds, mid clouds and low clouds. *What kinds of clouds are casting their shadows above the mill?* Does it look like it might rain?

East Anglia is often called 'Constable country' because the artist painted it so frequently.

FUN FACT

Two years earlier, in 1815, the Duke of Wellington, the 'Iron Duke', had defeated Napoleon at the battle of Waterloo. A new law banned the import of foreign wheat so one could only eat what was produced in the British countryside. Mills like Flatford played an important role in food production.

Although Constable never left Britain his paintings were shown in Paris. French Romantic and Impressionist artists admired his work for their intimate understanding of nature and their freshness. Whose point of view do you prefer: Constable's countryside, Turner's drama (see page 106) or Cole's fantasy (see page 90)? None of these artists followed the strict rules of the painting schools or academies. They followed their own ideas and visions; that is what makes them Romantic painters.

CONSTABLE

Flatford Mill belonged to his father, so **Constable** knew the place well. He loved the landscape of his childhood and visited every summer. In the winter he lived with his large family in London. Constable never sold *Flatford Mill* and his daughter donated the painting as a gift to the nation and it now hangs in Tate Britain, London.

Signed Jon Constable.
F: 1817

THE SCREAM

What comes to mind when you look at *The Scream*? Have you ever seen something so beautiful in nature that your jaw literally dropped? When this happened did you turn away from it to tell someone how you felt? When you can't find the right words to describe how you feel, do you draw a picture?

THE SCREAM

Who is screaming? Is the person covering his ears because he feels nature's scream or is he the one screaming? **'O'** Look at the shape of the mouth. Is it a happy scream or an anxious one? He seems to be swept into a whirlpool of nature and emotions.

This picture is also called *Scream of Nature.*

Do you think the people at the end of the bridge feel the same way?.

Is this person young or old, woman or man, boy or girl? We don't know! It could be all of the above. It can be whoever you want it to be, perhaps even you!

THE POWER OF LINE

With a few lines Munch drew a powerful image of a person in a state of panic. He drew those long sweeping lines of pure colour directly on to the cardboard.

The colour of the cardboard is integral to the picture. You can see it everywhere: the skin tone of the person is made up of the colour of the cardboard. There is not much colour in the face. The little wrinkles of the cardboard add to the texture.

LAND OF THE MIDNIGHT SUN

What time of the day do you think it is?

Has the sun just dropped behind the horizon line?

The warm colours of the midnight sun are awe-inspiring.

The Scream is one of the most **haunting** images in our visual history. Do you think you can ever forget it?

FUN FACTS

- In Norway in summer the sun sets around 11p.m. and rises at 4a.m. The light can affect people's moods and sleep.
- During the winter it is the opposite. Children go to and from school in the dark.
- Norway's landscape is stunning and some fjords are on the list of the UNESCO World Heritage Sites.
- There are four versions of *The Scream* including this pastel. The others are in museums in Norway.

MUNCH

<u>Edvard Munch</u> had a tough childhood. Both his mother and his sister died when he was young. He painted what he had experienced and in his work he expressed how he felt. Munch wrote this poem on the frame of the picture:

I was walking along the road with two friends. The Sun was setting –
The Sky turned a bloody red
And I felt a whiff of Melancholy – I stood
Still, deathly tired – over the blue-black Fjord and City hung Blood and Tongues of Fire
My Friends walked on – I remained behind
– shivering with Anxiety – I felt the great Scream in Nature
E.M.

Signed and dated lower left:
E. Munch 1895

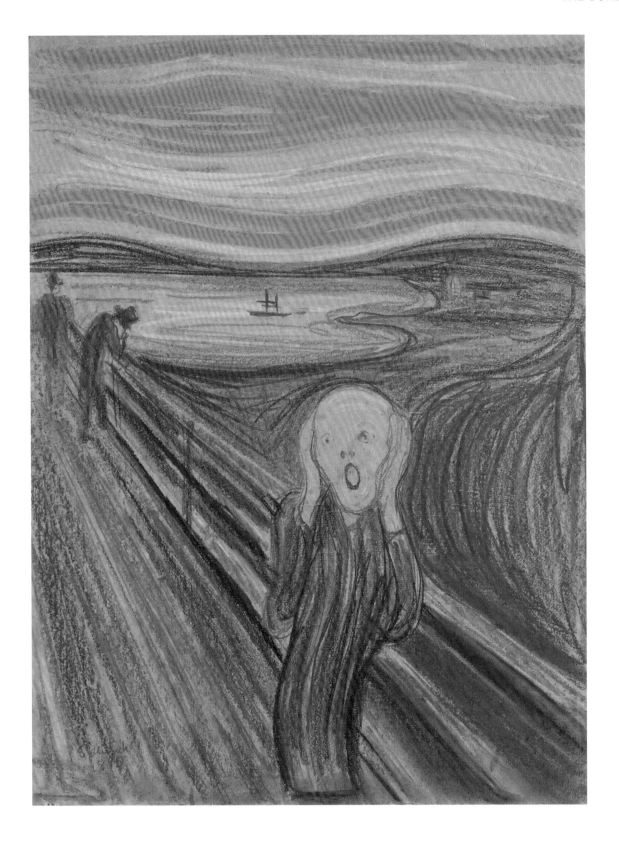

Edvard Munch (Norwegian, 1863–1944)
The Scream, 1895
Pastel on board, 79 × 59cm (31 × 23¼in)
Private Collection

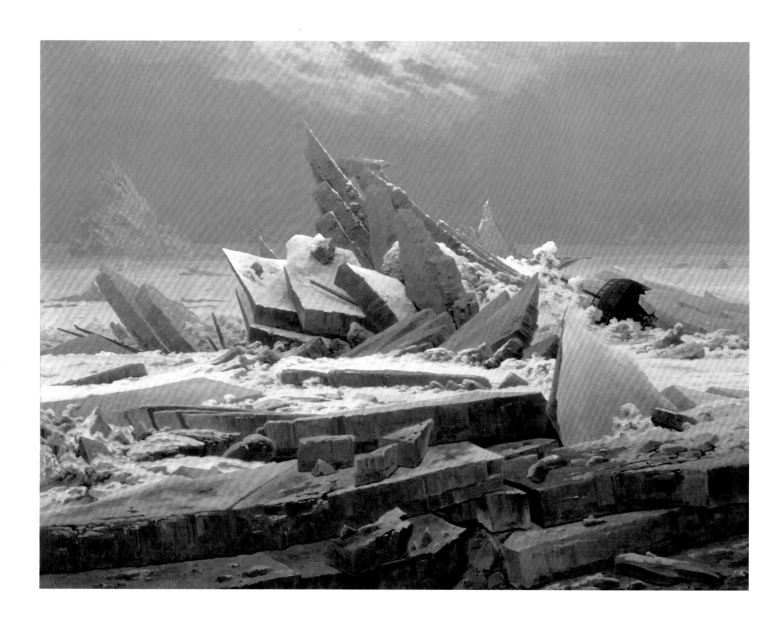

 Caspar David Friedrich (German, 1774–1840)
The Sea of Ice, 1823–4
Oil on canvas, 97 × 127cm (38 × 50in)
Kunsthalle Hamburg, Germany

ICE

You are on the top of the world: the North Pole. Large chunks of ice are colliding. ➔ Can you spot the shipwreck? The temperature seems to vary through the painting. *What is the coldest area?* The background looks absolutely freezing. The sky is icy blue. If you touched the tips of the icebergs would you cut your finger? *Does the foreground feel slightly warmer?* Might the brownish earth colour indicate that land is near? *Is there hope for survival?* Imagine the earsplitting noise of the collision! *Do you find the centre area where the icebergs are colliding, frightening?*

Which is stronger, nature or man?

ICEBERGS

An iceberg is a floating mass of ice. Large chunks of ice in the sea are called floes. Here floes collide and are pushed upwards, forming a jagged line of ice chunks. Navigating the Arctic Ocean is dangerous as the ice is constantly moving. ➔ *Do you remember the ill-fated ocean liner* Titanic *that struck an iceberg near Newfoundland on its maiden voyage to New York in 1912?*

THE TOP OF THE WORLD

The North Pole is in the middle of the Arctic Ocean. Noone owns it and it is uninhabitable as there is no land, just ice. Scientists work in temporary, portable labs. *Can you name some of the countries that surround the North Pole?* The Arctic sea ice keeps the earth's climate balanced and cool.

There is plenty of animal life. *Can you think of some arctic animals that live in the frozen north?* There are birds, fish, sea mammals and land animals. *Are there any animals in this picture?*

INSPIRATION

Friedrich never visited the North Pole, however, he had read about William Parry's 1819 Arctic expedition. The shipwreck in the painting refers to one of Parry's boats, the HMS *Griper*.

During a very cold winter in Dresden, Germany, Friedrich saw large packs of ice floating on the River Elbe. This inspired him to create the painting. *What time of the year is it in the picture? Is it the coldest month or during the warmer season?*

Do you think the artist caught the spirit of the North Pole?

FUN FACTS

• Glaciers are masses of ice that are formed on land. They are made of freshwater which is denser than saltwater. The older the glacier is, the denser and heavier the ice.
• Calving is when a piece of ice breaks off a glacier.
• The North Pole is warmer than the South Pole.
• In the North Pole the sun only rises and sets once a year. This is called the Equinox. The sun rises in March and sets in September.

FRIEDRICH

Friedrich had a spiritual view of nature and his pictures are often emotional. He is considered the greatest German Romantic painter. See how Friedrich's vision of nature is different to that of the other Romantic landscape painters in this book, Turner (see page 106), Constable (see page 24) and Cole (see page 90).

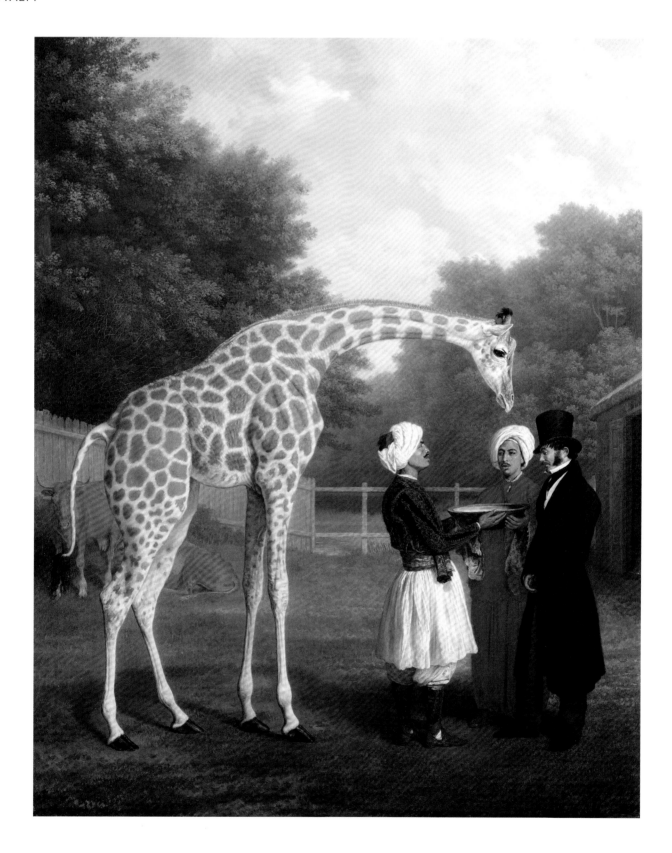

 Jacques-Laurent Agasse (Swiss, 1767–1849)
The Nubian Giraffe, 1827
Oil on canvas, 127.3 × 101.7cm (50 × 40in)
Royal Collection Trust

THE ROYAL GIRAFFE

In 1827 the Pasha of Egypt gave King George IV of England an unusual gift: a **giraffe**. The journey by boat from Egypt was not easy for the giraffe. When she arrived in England her neck was injured and she could not stand without the support of a pulley. The young giraffe was then moved to the king's menagerie at Windsor Castle, where she joined other exotic animals such as emus, ostriches, parrots, antelopes, wildebeests and wapitis (a type of deer). She was only 18 months old when she came to Britain and she measured just over 3 metres (nearly 10 feet). She was the king's favourite animal.

LUNCH IS SERVED

What does a young giraffe eat for lunch? *Can you see a clue?* What are the two cows in the picture for? They travelled with her and supplied the milk on the journey.

Two Egyptian keepers are showing the zookeeper the 'milk of the day'. *Do you think the giraffe is hungry? Will she drink the milk from that bowl?*

Have you ever seen such elegant and exotically dressed zookeepers? *Look at the men's expressions: which one do you think knows the giraffe best?* The British zookeeper looks a bit sceptical. *Is the house on the right shelter for the cows or for the giraffe? Will the giraffe be warm enough?* The English climate must have been quite different from warm and sunny Egypt.

Spot two Egyptian cows

Look at the men's expressions: who knows the giraffe best?

The king could often be seen riding around Windsor Great Park in his chaise admiring his exotic animals including his pet giraffe. London Zoo opened to the public in 1828. Until then exotic animals were kept in the monarch's private menagerie.

FUN FACTS

- Giraffes have the same number of bones in their neck as you do (7).
- The female's horns are thin and tufted; the male's are bald.
- They have four stomachs.
- Giraffes snort and moan
- Baby giraffes are c.180cm (5.9ft) when they are born. This is the height of a tall adult.
- Giraffes only sleep for a few minutes at a time for fear of predators like lions.

AGASSE

The young **Agasse** travelled from his native Geneva to Paris. It was the place to be for a young artist. However, Agasse did not go to art school but instead chose veterinary school where he could study the anatomy of animals.

An Englishman was so impressed with Agasse's work that he asked him to return to Britain with him. Agasse became the most celebrated animal painter of his time. King George IV admired his work and chose him to paint his most precious animal, the giraffe.

Signed with initials lower right JLA

QUEEN OF ROSES

Who is the woman in this picture? She is wearing a simple belted shirtdress made of layered muslin, very different to the usual rich dresses worn by ladies of the time. *Do you like the matching ostrich feathers and silk ribbons that adorn her straw hat?*

➜ *Do you think she is a flower girl or a lady of leisure?* She is not a peasant. Meet Marie Antoinette, the queen of France!

A RETREAT

When someone is bothering you, do you retreat to your room? At the Palace of Versailles, many people bothered the queen. They never left her alone, not even when she took a bath. The Petit Trianon, in the grounds of Versailles was her retreat and roses were her passion. At the Petit Trianon she could be herself and wear what she wanted. No one was admitted without her permission.

FUN FACT

In the late eighteenth century puffed-up hair called the 'pouf' (French for 'raise') and wide, heavily-structured dresses were all the rage. Women piled up their powdered hair, sometimes over 1m (3ft) high, and placed all sorts of objects including large model ships on top! Remember the 'pouf a la rhinoceros' (see Oudry's 'Miss Clara', page 20). In this picture Marie Antoinette wore a simpler hairstyle. After having children she lost some hair and had it cut shorter. She named the style 'coiffure a l'enfant', a child's hairdo!

FRIENDS

Vigée Le Brun painted over thirty pictures of the royal family. The artist and the queen spent a lot of time together and became friends. Vigée Le Brun was a magician with her paint brush and depicted the queen much prettier than she actually was. The queen had a large protruding chin, nicknamed the 'Hapsburg jaw'. Most members of her Hapsburg family suffered from this deformity, some of them so badly that it made chewing and speaking difficult.

THE SWAP

The artist exhibited the work at the Salon exhibition in Paris. However, visitors were outraged at the queen's informal dress and thought she was wearing her underwear. The artist quickly painted another portrait and swapped the pictures at the exhibition.

THE SUMMER OF 1783

That summer was the hottest on record in northern Europe. A gigantic volcano had erupted in Iceland and this had affected the climate. Acid rain was pouring down on Europe and the air was heavily polluted. Crops were destroyed and livestock died. The farmers were devastated. These miserable conditions contributed to the French Revolution.

REVOLUTION

Over time, some of the French people began to resent the Austrian-born queen, Marie Antoinette and King Louis XVI. They saw them as frivolous spendthrifts, who did nothing to help some of the French people, who were suffering from hunger and poverty. In 1789 the people's anger escalated into the French Revolution. The royal couple lost their heads on the guillotine.

VIGEE LE BRUN

Elisabeth Louise Vigée Le Brun was a hugely successful artist. She painted many influential people. During the Revolution she fled from France and worked in other countries. After the Revolution she returned to France where she lived and worked for the rest of her life.

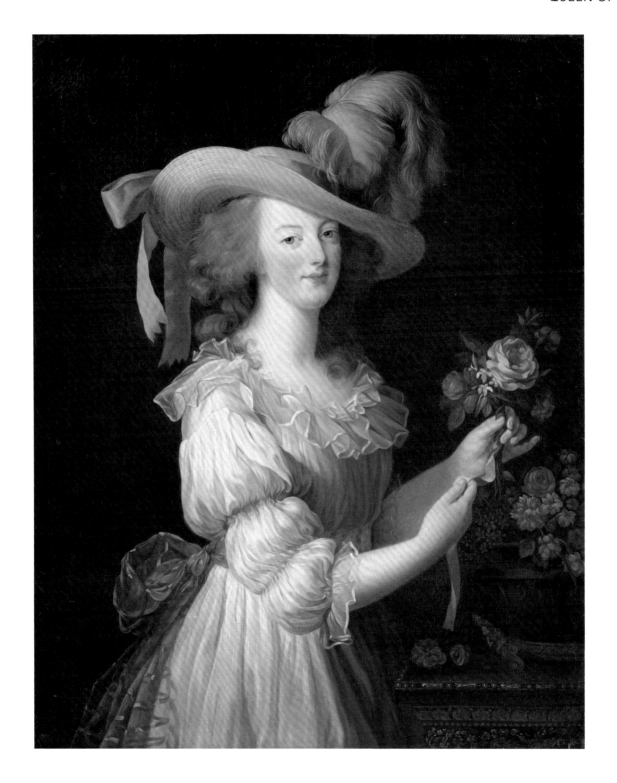

Elisabeth Louise Vigée Le Brun (French, 1755–1842)
Marie Antoinette
Inscribed on the reverse: *Marie Antoinette Reine de France et Navarre, née Archiduchesse d'Autriche,*
fille de l'Empereur François I et de Marie Therese peint par Mad. Le Brun
Salon of 1783
Oil on canvas, 93.5 × 79cm (37 × 31in)
Hessische Hausstiftung, Kronberg, Germany

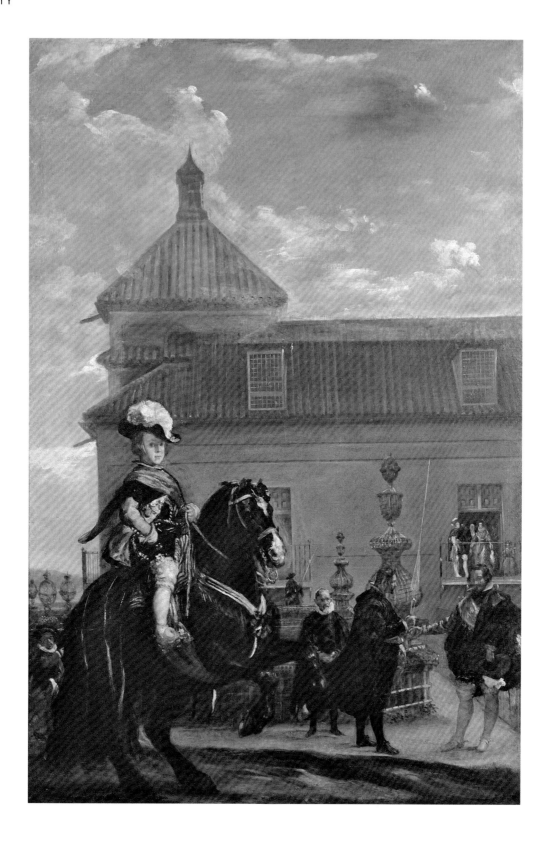

 Diego Velázquez (Spanish, 1599–1660)
Don Baltasar Carlos in the Riding School, 1636
Oil on canvas, 144 × 96.5cm (56¾ × 38in)
Private Collection

THE RIDING SCHOOL

Imagine: you are in a riding school in Madrid, looking up at a boy on horseback. He is only seven years old. Does he look **huge** compared to the building and the other people? *Would you ride up to him and challenge him to a race?* Does his posture show confidence and poise? *Or is he a bit shy underneath the fancy garb?* Velázquez paints a boy who has **power**. *Who is this boy?*

His name is Prince Baltasar Carlos and he is the only son of the King Philip IV of Spain and his wife, Isabel. *Can you spot his parents?* They are standing on the balcony watching their son display his equestrian skills. *Do you think they are pleased with his progress?*

> *Is the boy about to fall off the horse?*

THE HORSE

Why is the plump horse rearing? In fact he is performing a complicated 'dressage' movement. Baltasar Carlos has asked his horse to raise his front legs off the ground and to balance all his weight on his hind legs. *Is Baltasar Carlos in control of his horse?* Next, the boy is going to practise galloping at full speed towards a target while holding a lance. *Do you think the boy's plumed hat will stay on his head?*

FUN FACT

Dressage is French for training. It has its roots in ancient Greece and the modern form evolved in the sixteenth century. It requires great skill and an intense relationship with the horse.

THE COURT

➡ Can you see a dwarf? Dwarfs had a special role at court. Towering over a small person would make the king look even more powerful and intimidating.

Behind the boy is a valet handing a lance to Gaspar de Guzmán, the Count-Duke of Olivares. After the king, he is the most powerful man in Spain. He and his wife are in charge of the prince's education. The man behind the valet is the Master of the Hunt.

HOW WAS IT PAINTED?

Did Velázquez paint the scene outside? He probably placed the child on a wooden horse in his studio. *Did he paint the horse in the stable or bring him to his studio?* Look at the area around the head of the boy and the horse. You will find a number of *pentimenti*. These are areas where the artist changed his mind and painted over a previous design.

Velázquez's art is lively and fresh and his brushstrokes are free and loose. *Does the brushwork look modern to you?* He dabbed sparkling highlights on top of the final thin glazes of paint.

VELAZQUEZ

Olivares had introduced **Velázquez** to the king, who then employed him. Velázquez travelled to Italy to study art and buy works of art for the king.

Rubens (see page 52) came to Madrid in 1628 and remained there for six months. The two giants of Baroque art liked and respected each other. They did not, however, have much influence over each other's work.

Many artists, including Manet (see page 84), admired Velázquez's art. Velázquez's *Las Meninas*, in the Museo del Prado, Madrid, is considered to be a cornerstone of Western art and his masterpiece.

A STROLL IN THE CITY

This scene takes place in the Place de la Concorde, one of the most beautiful spots in Paris. The girls are out for a stroll with their father. The man in the picture is an artist called Lepic who was a friend of the artist Degas. *Does he look like a bohemian artist or more like an elegant dandy with his top hat and the flash of red just visible at his lapel?* Smoking cigars was commonplace at this period. *Is it about to rain or is Lepic carrying his umbrella because it looks stylish?* ➡ *Do you think the man on the left is someone the family knows or perhaps just a passer-by?*
Instead of cars racing by, people had to watch out for horse carriages. It may be best to put the dog on a leash so he doesn't spook the horses!

What seems new and different in this picture? Are these people posing or are they walking by without noticing us? The picture is reminiscent of a random photograph taken on the street. Photography had already been invented and the new machine that could take pictures fascinated modern artists in Paris. Degas became a passionate photographer in the 1890s.

ART DETECTIVES
What season of the year do you think it is?
 ➡ Look at what they are wearing. Do they look as if they are dressed for the heat of summer?

FUN FACT

The Place de La Concorde is a famous square in Paris. 'Concorde' means harmony, but it hasn't always been a peaceful place. During the French Revolution, Marie-Antoinette (see page 32) lost her head on the guillotine. Today, in the park there is a beautiful Egyptian obelisk instead.

THE MAGIC OF PARIS
Paris was Degas' inspiration. In the daytime he went to the races to watch the horses, visited street cafés and hat shops. His nightly entertainment was the ballet and the opera. His paintings reflected his life and he painted the activities of modern life. He is famous for studies of dancers.

HIDDEN TREASURE
This picture belonged to a collector called Otto Gerstenberg in Berlin. At the end of the Second World War the Russian Army seized his art collection and it was hidden from view for fifty years. This painting is now on view at the State Hermitage Museum in Saint Petersburg.

DEGAS

Degas was born in Paris to a creole mother from New Orleans and a French father. His parents wanted him to become a lawyer. At first he followed their wishes and went to law school but his real passion was painting. His bedroom looked like an artist's studio. He admired Ingres (see page 46), who advised him to practise drawing. At nineteen he abandoned his studies and focused on his art full-time.

He visited New Orleans where he painted his American relatives. Look up *A Cotton Office in New Orleans* (Musée des Beaux Arts, Pau).

He was friends with Manet (see page 84) and Cassatt (see page 38). Although often called an Impressionist, Degas thought of himself as an independent artist or a Realist. He admired the Old Masters more than his contemporary Impressionists.

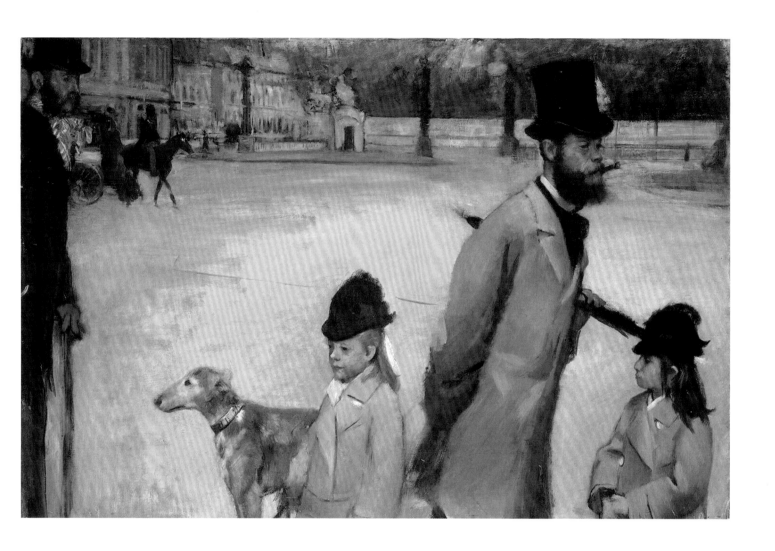

Edgar Degas (French, 1834–1917)
Place de la Concorde, 1875
Oil on canvas, 78.4 × 117.5cm (30¾ × 46¼in)
On view at the State Hermitage Museum, Saint Petersburg

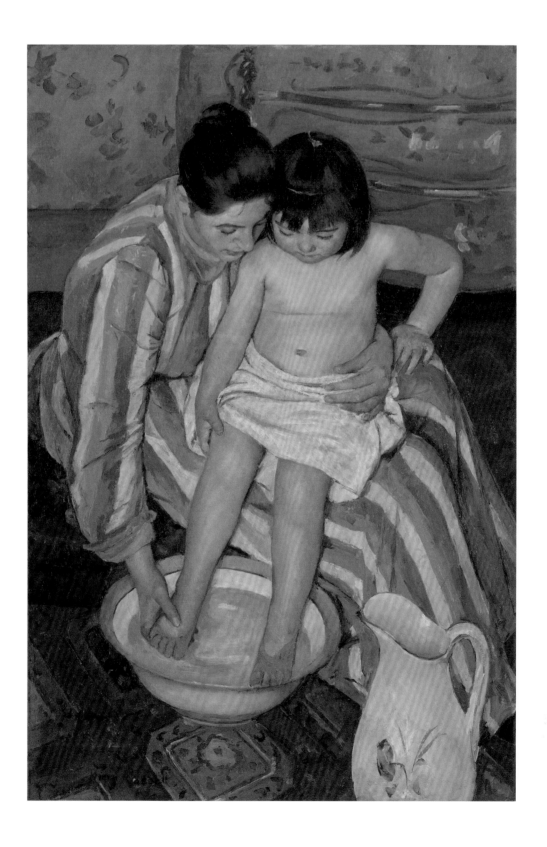

 Mary Cassatt (American, 1844–1926)
The Child's Bath, 1893
Oil on canvas, 100.3 x 66.1cm (39½ x 26in)
The Art Institute of Chicago, Robert A. Waller Fund

ROCK-A-BYE BABY

Sitting, balanced on her knee, a woman washes a child and wraps her up in a towel. Does this scene remind you of when you were small? *Is this woman sitting on a cushion or on the rug?* Wait, where's the soap? Will she need more water from the jug?

Has the baby had her bath or is she just about to start?

There is a scene in the film *Mary Poppins* where Uncle Albert, Bert, Jane and Michael are laughing so hard that they are propelled to the ceiling, from where they take tea with Mary Poppins. Mary Cassatt seems to be painting this picture as if from the ceiling. She is looking down on the woman and baby who are totally absorbed in the activity.

The baby is looking at her right foot. This angle makes her chubby-cheeked features look small and wide. *How old do you think the girl in our picture is?* Does she have strong leg muscles? *When she stands up will she walk by herself or do you think she still needs to hold her mother's hand?*

FUN FACT

Why do babies have big tummies? A baby's stomach sits sideways in the abdomen. Only at the age of two does it shift to a vertical position.

PATTERNS

Mary Cassatt loved the Japanese prints and patterns that arrived in nineteenth-century Paris. *How many different patterns do you see in the picture?* Do the stripes of the woman's dress look as though they continue in the washbasin? ➜ Look at the whites – they are almost blue. Everything is clean, even the water. *Can you name some different shades of green?*

ART ADVISER

While in Paris painting, Mary Cassatt also helped her American friends buy art. Her friend Louisine Havemeyer bought many great Impressionists on her advice. Those pictures are now the cornerstone of the Metropolitan Museum of Art's Impressionist collection in New York.

CASSATT

There are not many women in the history of Western art. **Mary Cassatt** came from Pennsylvania, USA. Against her father's wishes she studied to become a painter but when some of the men at the Philadelphia art school were condescending to her Mary decided to go to Paris. In the late nineteenth century it was unusual for a single woman to leave home and live the 'bohemian' life of an artist.

At the beginning of her time in Paris Mary called herself Mary Stevenson. She exhibited with the Impressionists and became a close friend of Edgar Degas (see page 36). She loved painting mothers with their children. Before this period women from Mary's background would not have taken care of their children themselves, instead they were looked after by nannies.

Signed lower left
Mary Cassatt

PLAYING KINGS & QUEENS

Picture yourself in St James's Palace, London, nearly 400 years ago. You are a royal prince or princess – one of the children of King Charles I. *Which figure would you like to be?* Today is a big day! The most famous portrait artist in England is about to paint you with your siblings and dogs. *Would you wear those colours? Can you run in those shoes?* ➤ How would you want van Dyck to make you look: powerful, studious, playful, charming or simply regal? *Will you be well behaved or might you throw a royal temper tantrum if it takes too long?*

It may be difficult to get the mastiff and the King Charles spaniel to sit still. Perhaps the baby wants to ride the enormous mastiff like a pony.

If you get hungry you could eat the grapes on that high table.

ART DETECTIVE

Who is a boy and who is a girl? **Hint:** The pearl necklaces give it away.
Who will be the next king of England? As a matter of fact both boys will become kings: Charles II (King of England, Scotland and Ireland) and James II (King of England and Ireland and King of Scotland as James VII).

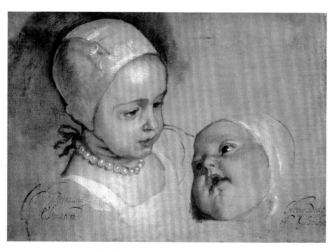

Princess Elizabeth and Princess Anne, 1637
Oil on canvas, 29.8 × 41.8cm (11¾ × 16½in),
Scottish National Portrait Gallery

Signed and dated mid-left
Anthony van Dyck
Eques Fecit 1637

What would you like to do after van Dyck has finished sketching you? You can do what you like, as there won't be any lessons today! *Will you run through the opening behind you and play tag in the garden with the dogs?* Might you play royal 'sardines' and hide behind the green velvet curtain? You could get your favourite pony and go riding in the park.

HOW WAS IT MADE?

Van Dyck made studies, such as the sketch (bottom left) of the two girls on the right. Then he built up the paint with glazes. Van Dyck's pictures were so much in demand that he had to work quickly. In some pictures assistants helped with the trees or the costumes, however, van Dyck always painted the faces and hands. It was not considered cheating. It is the way a successful portrait painter worked.

VAN DYCK

Young **Antoon van Dyck** was very talented. Aged fourteen years old he entered the Antwerp studio of the great Flemish artist, Sir Peter Paul Rubens (see page 52). He travelled to Italy to study the great Italian masters. King Charles I of England invited van Dyck to move to London in 1632. There he was knighted and changed his name to *Sir Anthony van Dyck*.

Van Dyck's work was much admired. Look at Gainsborough's (1727–88) *Blue Boy*, in the Huntingdon Library, California, to see how he influenced other artists.

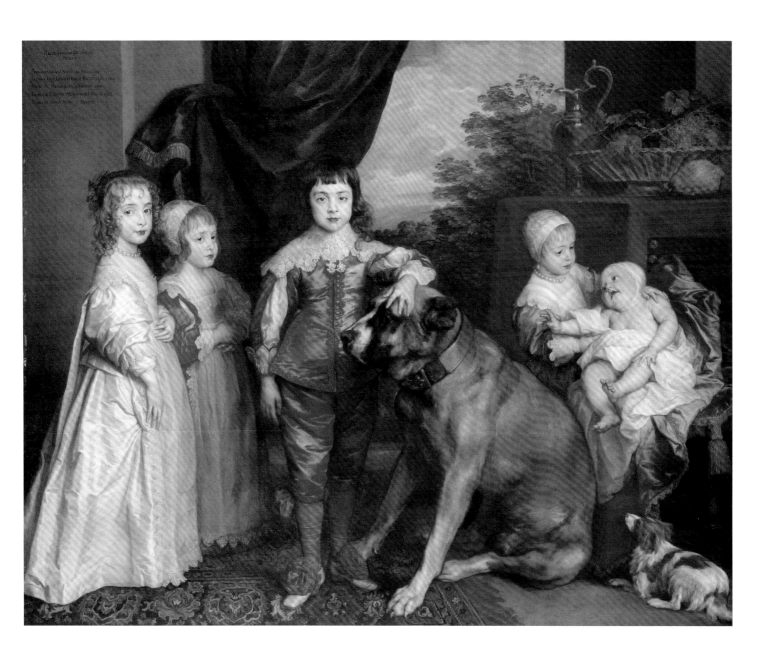

Sir Anthony Van Dyck (Flemish, 1599–1641)
The Five Eldest Children of Charles I, 1637
Oil on canvas, 162.2 × 198.8cm (63¾ × 78in)
Royal Collection Trust

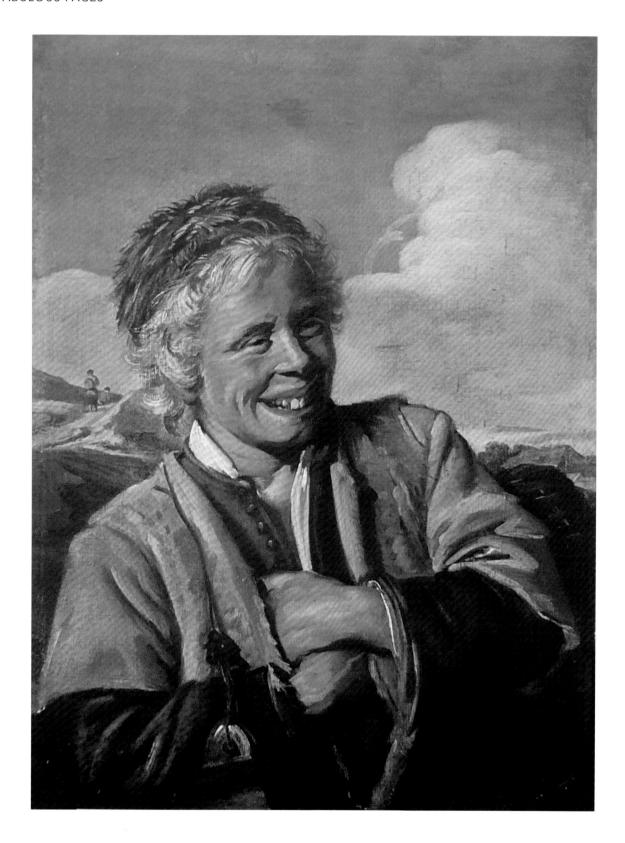

 Frans Hals (Dutch, 1582/3–1666)
Laughing Fisherboy, c.1627–30
Oil on canvas, 82 × 60.2cm (32 × 24in)
Private Collection

THE LAST LAUGH

Would you like to play with this boy and go fishing with him? The boy's **laugh** is **contagious**! Do you think he was posing in the studio or standing on the windy dunes when Hals painted him? The clue is in the background: which looks like the backdrop of an old film set. Two people are walking on the dunes, going home at the end of the day perhaps.

hahahaha!

a sure hand and often painted with his broad and swift brushstrokes directly onto a prepared ground (without under-drawing).

Some people thought his brushwork was sloppy. Later artists like Manet (see page 84) thought this was modern.

No drawings by Hals exist today.

ART DETECTIVES

➡ *Can you identify the tool hanging from his shoulder? Why is the boy laughing? Is he hard-working or lazy?* Find the clue.

THE HANDS

Can you see the veins in his hands? Is he warming his hands from pulling fish from the freezing waters of the North Sea? Careful, perhaps he is tricking us!

Every gesture, pose and detail in Dutch art of the seventeenth century is loaded with a hidden meaning. The boy has rosy cheeks and a big laugh, but he is not looking at us. Could this be a clue that he is deceiving us?

Researchers have discovered that the pose of the boy leaning back, hands tucked in his jacket means that he is a lazybones. Hals tricked us: the last laugh is on us.

THE PAINTING

How many different width paintbrushes did Frans Hals use? Look at the brushstrokes. Hals set his paint brushes aside when he felt a picture was 'just right'. He didn't paint his pictures 'to death'. He had

HALS

Frans Hals lived in Haarlem, which is near the coast in the Netherlands. He saw many fisherboys and girls at work. Hals painted around the same time as Rembrandt (see page 78) and Vermeer (see page 70). He loved painting the important citizens of his town as well as the ordinary people.

Hals wanted to capture the mood of the moment and was not interested with too much detail. Other artists of his time painted people looking more serious. They paid great attention to the details whereas Hals was more interested in his sitter's emotions.

You can see more works by Hals at:

www.franshalsmuseum.nl
www.metmuseum.org
www.wallacecollection.org

Signed with monogram on the jug hanging from his shoulder: FHF (the last F stands for 'fecit', which means 'he made it' in Latin.)

GOOD DAY SIR JOHN

How do you do, Sir John, would you shake my hand? He can't right now because he is holding a letter. His forearm is resting on a ledge. *Does this give the impression that he is about to hand the letter to you?* Or perhaps he is about to hide it in his coat instead?

Holbein uses line and the minimum of colour to depict the features of Sir John, who has sharp cheekbones, deep-set blue eyes and a rather big nose. ➡ Look at the shadows and see where the light is coming from. *Does the picture seem unfinished?* Or did Holbein paint it like this on purpose? *Do you like it the way it is?* Holbein does not want to distract us with details. He is keeping it simple because he wants us to focus on Sir John himself.

> What do you think Sir John is about to say?

THE STORY

Can you tell a story about Sir John by looking carefully at his face?

What do you think his family is like?
Describe his relationship with his parents.
What kind of work does he do?
What does his house in London look like?

This is what we know about him: Sir John was married with two children. He was an important person in King Henry VIII's court. He was in charge of precious cloths made of gold and silver. Later, he oversaw the Royal Mint, where they made coins.

FUN FACTS

- Do you like the beard stubble and the long hair, which was the fashion in sixteenth-century London?
- Only a year after this picture was painted, Henry VIII imposed a tax on men wearing beards.
- The king himself ignored his own order and wore a full beard.

CHARACTER

Looking at his features, how would you describe this 27-year-old man?
Do you think Sir John is

Funny • Serious • Honest • Nervous • Afraid • Shy • Fearless • Self-confident • Calm • Kind • Suspicious • Nasty?

THE LOOK

Sir John is wearing a simple white shirt, a blue jacket and a black, short-sleeved overcoat lined with fur, probably sable. The black cap has a small gold ornament.

Black was an expensive dye that only the richest people could afford to wear. It was also a signal that the person was an intellectual and reflective. The letter confirms that he was a learned man. All of these details give us clues about Sir John's social station in life. Sir John was thoughtful, intelligent and learned.

HOLBEIN THE YOUNGER

Hans Holbein the Younger was born in Germany. His father, Hans Holbein the Elder (1465–1524) was also a painter. Holbein the Younger worked in Switzerland and went to live in Britain twice. He worked for Henry VIII and painted the most influential people of his time.

He was one of the greatest portrait painters of the Northern Renaissance. He also painted some amazing religious pictures.

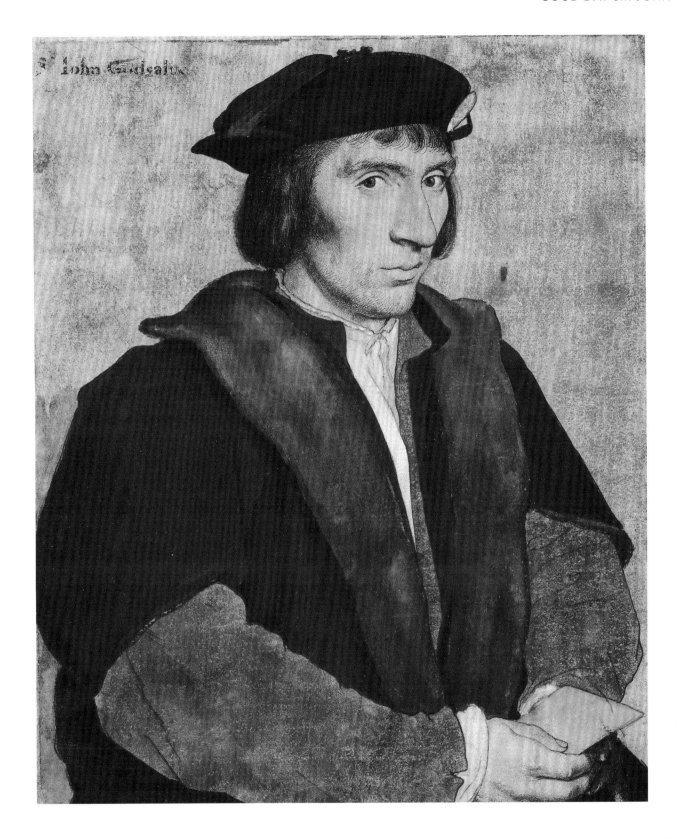

Hans Holbein the Younger (German, 1497–1543)
Sir John Godsalve (c.1505–56), c.1532–4
Black and red chalk, pen and ink, brush and ink, body colour, white heightening on pale
pink prepared paper, 36.2 × 29.2cm (14¼ × 11½in)
Royal Collection Trust

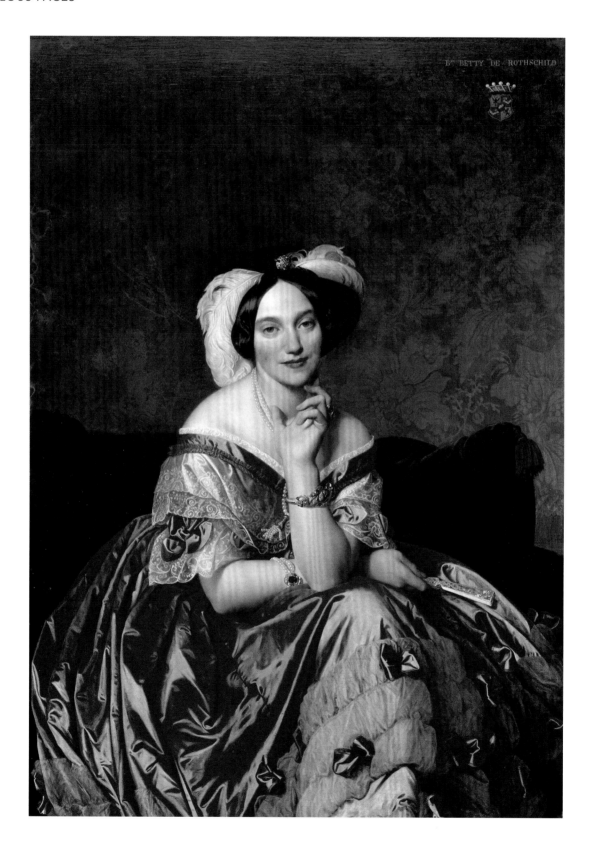

 Jean-Auguste-Dominque Ingres (French, 1780–1867)

Baroness Betty de Rothschild, 1848
Oil on canvas, 141.9 × 101cm (55¾ × 39¾in)
Private Collection

HIGH SOCIETY

Betty de Rothschild was a sophisticated young lady from Vienna. At nineteen years of age she married James de Rothschild from Paris. He was thirty-two years old, rich and influential. Betty and James lived in Paris, had a large family and gave glamorous dinner parties. Their guests were brilliant, the food was sublime and their living rooms resembled a cozy museum. Chopin taught Betty how to play the piano. Famous writers such as Stendhal and Balzac based characters in their novels on the young Rothschild couple.

THE PORTRAIT

Betty's portrait is one of Ingres' most arresting female portraits. He captures her character and her station in life. *How would you describe Betty's personality? Is she strict or lenient?* Cover the left half of her face and then the right side. *Do the two sides have different expressions?*

Where does the soft light come from? She is seated on comfortable wine-red velvet cushions. Her legs are crossed; she is leaning forward as if ready for your questions. *What would you like to ask her?* Perhaps you would ask her how to behave when you go to your first ball?

WHO IS BETTY?

Her dress is made of shimmering satin and lace. The soft rose hue perfectly matches Betty's colouring, her lovely cheeks and lips.

She doesn't overdo the jewellery nor does she show off. She prefers to be understated and never flaunts her wealth. *Do you like her little black hat with the white feathers that are fastened with a jewelled pin?*

At a time when dresses were so tight that a woman might faint from lack of oxygen, Betty wore clothes that left room to breathe. Betty's off-the-shoulder dress reveals a bit of flesh but not too much and she would not be seen in sky-high heels!

➲ *Do you think Betty has a tattoo?* Certainly not, she prefers the Rothschild coat-of-arms discreetly placed at the top right of the picture.

Above all Betty knows how to have an intelligent and witty conversation. She is charming, alluring, a little bit mysterious – and very cool!

INGRES

Ingres liked to paint history pictures but he was also brilliant at capturing a person's character. He was arguably the greatest portrait painter of his time. After many years of living in Rome he returned to Paris in 1841. His portraits were in high demand and it took Ingres six years to complete this portrait of Baroness Betty de Rothschild. He made many drawings to prepare for the painting. When he finished the picture, Betty was forty-three years old.

THE BANKER OF MODERN LIFE

This was the period of the industrial revolution. *In 1833 what would have been needed to build the first railway?* You would need scientists, engineers, workers, technology and materials. But you also needed money. Betty's husband James financed the new industries and the railroads in France. He could be called the banker of modern life. The new trains allowed people from all walks of life to travel about freely (see Manet page 84).

FUN FACT

Ingres originally painted Betty's dress blue and then changed the colour to a warm rose.

Signed and dated centre left: J. Ingres pinxit 1848. Inscribed upper right above the Rothschild coat of arms: Bne. BETTY DE ROTHSCHILD

THE JEWEL

Enter the shimmering aura of Adele Bloch-Bauer. *Would you like to be painted like a modern Byzantine icon, encrusted in gold?* How about if your face appeared transparent, your eyes the shape of two large almonds and your hands long and delicate?

What could the green floor on the left be made of, emerald or green marble?
Is Adele sitting in a chair or is she standing? It is hard to tell, but there is a chair behind her. *Can you see the contours of the big wing chair?*

ART DETECTIVES

There are several symbols and patterns in the picture. *See how many you can find.* Klimt admired Egyptian art where eyes are the symbol of protection from evil. *Can you count the eyes on her dress?* Above her head on the left is another pair of eyes; *whose eyes are they?*

On her flowing cape there are some gold encrusted letters. *Can you find them? What do you think they are?* They are the initials of her name A and B.

GOLD

Why has gold always been important to people?
It has to be mined.
It is shiny and does not tarnish.
It is soft. This means you can engrave it and mould it. Gold leaf is very thin and can be applied with a soft brush.
Can you think of expressions or fairy tales about gold?

HOW THE PAINTING WAS MADE

How long do you think it took Klimt to make the picture? It took him three years! He made many preparatory pencil drawings of Adele before beginning the painting. He then drew his design on to the canvas and applied adhesive on top of the lines. While the adhesive was wet, he gently brushed on the sheets of gold and silver leaf. When he dusted off the remaining leaf, the gold or silver design remained on the design.

Can you name some of the precious stones and metals in the picture?

THE LONG ROAD

In 1938 the Nazis stole all of Ferdinand Bloch-Bauer's possessions, including his art collection. The Klimts were then sold to a museum. The portrait of Adele stayed there until 2006. The Austrian government believed the museum owned it. However, the rightful owner was Adele and Ferdinand's niece and heir, Maria Altmann. Maria had fled Vienna from the Nazis and lived in the USA. Maria sued the government of Austria and won. Sixty-eight years after the theft her property was returned to her. The story has been turned into a film, *Woman in Gold*.

Maria Altmann sold the picture and today Adele is the jewel in the crown of collection at the Neue Galerie in New York. You have to be twelve years old to visit the museum, but the café has the best apple strudel and hot chocolate outside Vienna!

KLIMT

<u>Klimt</u> didn't like to chatter. He preferred to be silent and paint instead. Klimt's father was a gold engraver so Gustav had learned how to work with precious metals.

At the turn of the twentieth century Vienna was the place to be. Artists, musicians, writers and philosophers met in the cafés and discussed their groundbreaking ideas and Sigmund Freud helped people with their inner troubles.

Ferdinand Bloch-Bauer asked the most famous artist in Vienna, Klimt, to paint his wife Adele. Although Klimt portrayed many women in Vienna, Adele was one of the most glamorous.

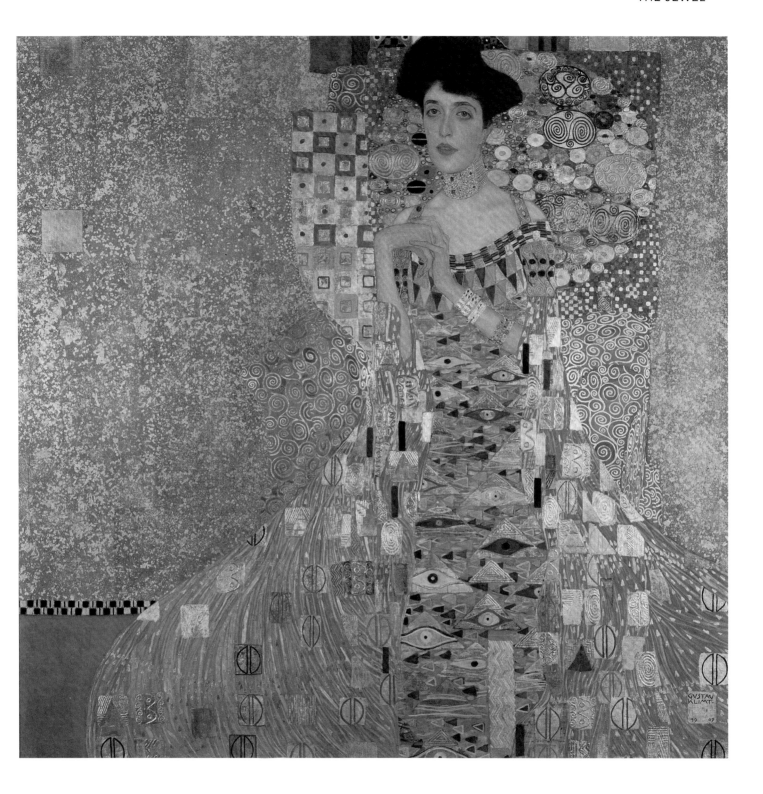

Gustav Klimt (Austrian, 1862–1918)
Adele Bloch-Bauer, 1907
Oil, silver and gold on canvas, 140 × 140cm (55 × 55in)
The Neue Galerie, New York

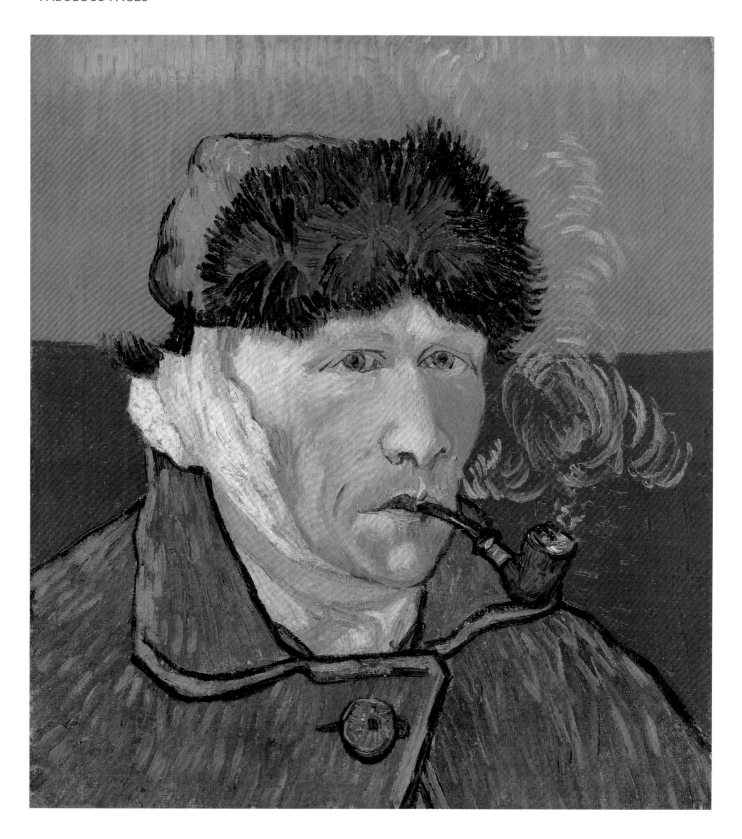

 Vincent van Gogh (Dutch, 1853–90)
Self-portrait with Bandaged Ear and Pipe, 1889
Oil on canvas, 49.5 × 44.2cm (19½ × 17½in)
Private Collection

VINCENT'S SELFIE

Have you ever taken a selfie with a cellphone? How about painting a **self-portrait**? Sit in front of a mirror and have a go at painting or drawing yourself. How would you want to appear on canvas: happy or sad or with a silly face? What background colours would you pick? When you paint your reflection, the image becomes flipped: right becomes left and left becomes right.

SELFIES

Vincent painted himself 37 times in different moods, but he never smiled. *Why did he paint himself so often?* It helped him to better understand the moods of other people.

What are the colours of his eyes? Perhaps the pipe smoke irritated his eyes and made the inside a bit red. *Or do you think that he has been crying?*

Rembrandt (page 78) holds the world record for self portraits with ninety.

COLOUR

When Vincent was a young artist in the Netherlands, his pictures were dark. He used mostly browns, greens, blues and blacks. His art burst into bright hues when he moved to France. He saw Impressionism in Paris and met other artists who were painting colourful pictures. In 1888 he moved to the South of France where the dazzling light and the lush vegetation made a deep impression on him. His friendship with Paul Gauguin also influenced his style of painting and his palette. *Do you think he was overly concerned with fine details or is this picture more about colour and mood?*

What are the main colours in this picture?

THE 'INCIDENT'

Vincent is wearing a bandage – *do you think he has a toothache?* The bandage is the result of an incident.

On December 23rd, 1888, Vincent had a fight with Paul Gauguin. The two artists had spent nine weeks together in Vincent's yellow house in Arles, in the south of France. In a crazy rage Vincent cut his own ear. *Which ear is wounded and bandaged?* Remember, this is a mirror image so it is the artist's left ear. Vincent painted this picture three weeks after the incident. *Would you wear a fur hat in the South of France where it is usually hot?* Perhaps the hat holds the bandage in place.

Does he still look agitated or has he calmed down?

VAN GOGH

Vincent's brother Theo lived in Paris and was his best friend. They wrote to each other often. These letters are very special, as they sometimes include beautiful drawings. Theo was Vincent's art dealer but only ever sold one painting by his brother during his lifetime. Now everyone would like to own a painting by this genius. Fortunately you can admire landscapes, bedrooms, and portraits of Vincent's friends in many museums today. Vincent is particularly known for painting sunflowers which he loved.

Van Gogh is considered an important Post-Impressionist and his work has influenced many subsequent artists. He is one of the most beloved artists who ever lived.

THE DRAGON SLAYER

Lights, Camera, Action! This is a Baroque action picture (rated PG). The horse is rearing up in fright; at its feet, a dragon is fighting for its life. A broken spear has pierced the dragon's mouth and snout and the wound is bleeding heavily. The monster pulls at the spear, trying to remove it. *Can you see his tongue curling around the spear?* A Roman soldier is about to strike the final blow. Will he kill the beast? A young woman holding a sheep cowers nearby.

This picture is **huge** – taller than your typical living room – so the figures are almost life-size.

ART DETECTIVES

What do you think the story is about?

➲ Look at the action!

THE SCRIPT

The Roman soldier in the picture is called George. According to legend, the dragon lived by a spring that was the only source of fresh water for the town. Each day the people gave a sheep to the dragon in order to distract it long enough for them to get the water they needed without being devoured. When they ran out of sheep, young girls were selected by a lottery and brought to the beast as sacrifice. One day the princess drew the sacrificial lot. This is the moment of the picture – when George comes to her rescue, slays the dragon and saves the princess.

THE COSTUMES

A mythical creature sits on George's plumed helmet, ready to pounce. *What is it?*

Do you notice anything missing? Instead of a saddle George sits on an animal skin. ➲*Can you identify the animal?*

George is riding bareback without stirrups. He is wearing gladiator sandals, and a garter around his calf is decorated with a mask of an animal. *Can you see which animal it is?*

A gold and blue silk tunic peeks out from underneath George's polished armour. His bright red cloak billows out behind him, emphasizing the action. The red draws the eye into the fight between George and the dragon.

SUPPORTING CAST

The horse is foaming at the mouth. *How long would it take to curl and brush the horse's gorgeous mane and tail?* Can you see how the artist used the tip of his paintbrush to scratch the curls into the wet paint.

The woman holding the lamb is the princess. *Does she look scared?*

WHO WAS GEORGE?

George was born around AD280 in present-day Turkey. This was a period of great unrest and Christians were being persecuted. George, a Roman cavalry officer, had converted to Christianity and he tried to protect their churches. He was arrested, tortured and beheaded for his beliefs. George was made a saint and is the patron saint of England.

PRIZE WINNER

Would you give Rubens the Oscar for Best Picture of 1608? In his time Rubens was more famous than Steven Spielberg is today. Rubens was a painter in the Baroque period and his action-packed pictures were seen in palaces, castles and churches all over Europe.

RUBENS

Like Saint George, **Peter Paul Rubens** was fearless – but as an artist. No picture was too big and no story was too scary for him for him to tackle. He was 30 years' old when he painted this picture in Genoa, Italy. Rubens was famous and worked for the crowned heads of Europe and the Catholic Church.

When you visit museums you will quickly spot Ruben's pictures. They are usually big and full of Baroque vim and vigour. The women he portrays are always well fed! He often made exquisite oil sketches for his finished paintings.

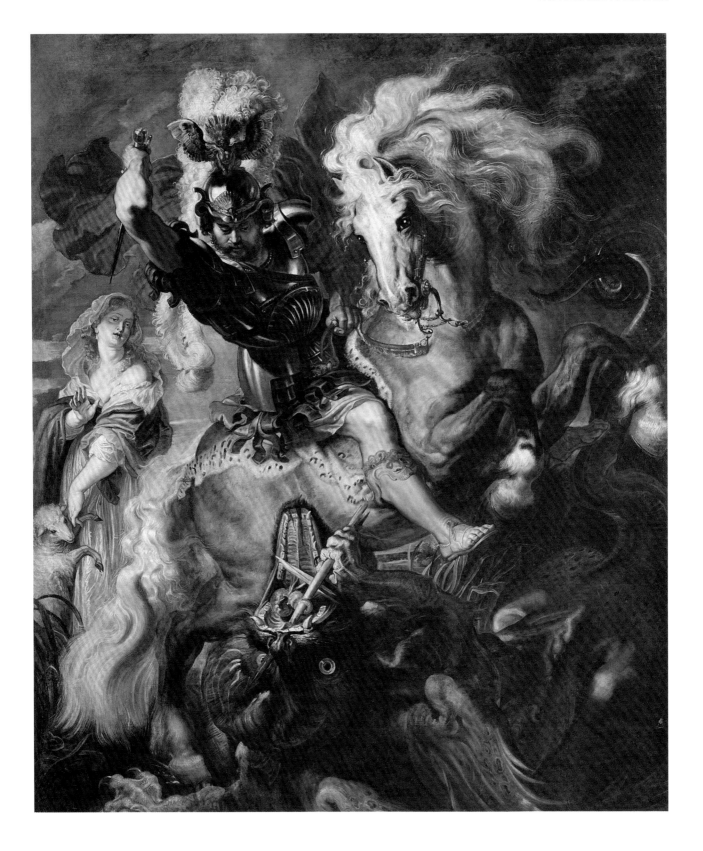

Sir Peter Paul Rubens (Flemish, 1577–1640)
Saint George and the Dragon, 1606–08
Oil on canvas, 309 × 257cm (121½ × 101in)
Museo Nacional del Prado, Madrid

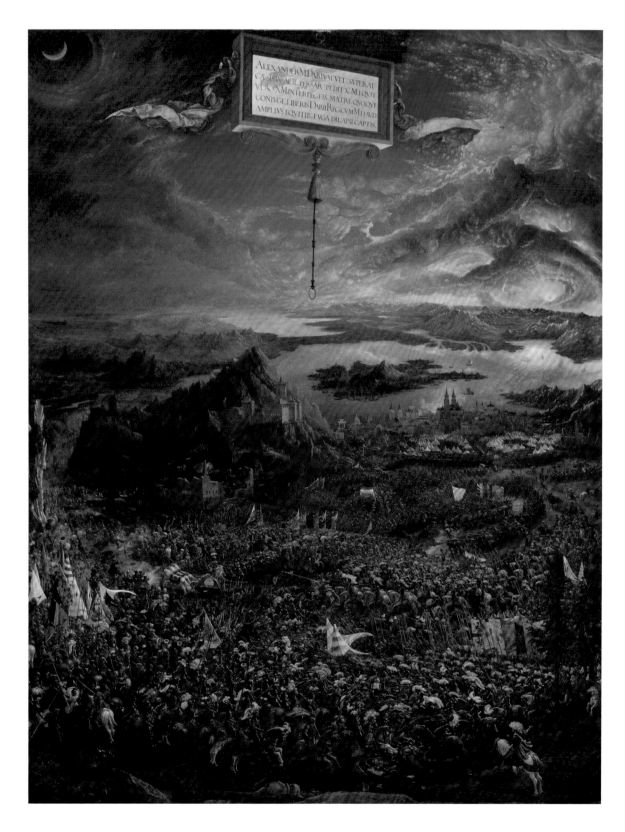

 Albrecht Altdorfer (German, 1480–1538)

The Battle of Issus, painted in 1529
Oil tempera on lime wood panel
158 × 120cm (62 × 47in)

Alte Pinakothek, Munich

MIDDLE EARTH

The scene in this painting is reminiscent of the fantasy battles depicted in blockbuster films such as *Lord of the Rings* and yet this picture was painted almost 500 years ago. The year is 333BC and the place is present-day Turkey, the battle is between Alexander the Great and King Darius of Persia.

ART DETECTIVES

Can you find the Persian King Darius in his chariot?

➥ Look for three white horses. Now look for Alexander, who is in hot pursuit. *What can you discover from the painting about the length of the battle?* The moon of the early hours of the morning and the sunset tell us that it lasted all day. *Can you figure out who won the battle?*

Whose army is larger – Alexander's or Darius's?

THE BATTLE

Thousands of horses are charging. Listen to the ear-splitting battle cries and the clash of weapons. Alexander's men are in full body armour. They are wearing plumed helmets. Darius's troops wear red uniforms and exotic turbans. They are riding their horses bareback. ➥ Look at the expressions on the soldiers' faces. *What emotions can you see?*

ALEXANDER'S EMPIRE

On the outskirts of the city there are tents; find them and follow the ramparts, past the fortress and climb the castle tower – from there there is a good view of Alexander's future empire: Cyprus lies in the centre of the Mediterranean Sea. The Nile Delta has seven arms. *Can you find the Sinai Peninsula?* The Tower of Babel (page 98) is in the shadow on the left. Altdorfer's world ends with the Red Sea. At the horizon you can even make out the curvature of the globe.

With this victory, Alexander the Great's empire became the largest of the ancient world. It encompassed Persia, Egypt, Greece and Babylon.

Signed

lower left with monogram: AA and signed lower edge: 'Albrecht Altdorfer Zu Regenspurg Fecit'

THE SKY

The clouds burst open and a tablet describes the scene (*are you tempted to pull on the cord?*):

> Alexander the Great defeating the last Darius, after I00,000 infantry and more than I0,000 cavalrymen had been killed amongst the ranks of the Persians. Whilst King Darius was able to flee with no more than I,000 horsemen, his mother, wife, and children were taken prisoner.

FUN FACTS

- The battle took place 1,800 years before Altdorfer painted it.
- Alexander was twenty-three years old at the time.
- He always rode alongside his men in the front ranks.
- Alexander never lost a battle.

ALTDORFER

Altdorfer was a Northern Renaissance painter from Bavaria, Germany. He was one of the founders of European landscape painting as a genre. Altdorfer took some artistic liberties when depicting the battle as he wanted to convey the magnitude of the event.

His painting was so important to him he even turned down the post of mayor of this town to complete a commission.

ARABIAN KNIGHTS

Eugène Delacroix and his companion, a French diplomat, had been invited by the Sultan of Morocco to watch an exciting military exercise. Horsemen are galloping at full speed. Thundering hooves fill the air. Suddenly, a horseman fires a shot. ➋ *Can you spot him?* Two stallions have broken ranks. At the sound of the gunshot they rear in fright and collide. This is dangerous. If the riders pull on the reins too hard the horses may fall backward and crush them. The scene is full of screaming, dust, sweat and the horses snorting loudly.

THE PAINTING

Is this picture about high or low energy? Look at the swift bush strokes. In some areas the paint is thick and opaque and in other parts it looks liquid. If you look carefully you can even see some paint drips.

Delacroix uses a lot of different colours. Pick a favourite area of the painting and you will be amazed at the many different shades you can find.

ROMANTIC

What is important to this artist? There are four right answers and one wrong answer.

1. Atmosphere (how it feels)
2. Colour
3. Detail
4. Action
5. Composition (the placement of the horses and riders on the canvas)

[The wrong answer is number 3]. Detail is irrelevant to Delacroix. Instead, he wants us to *feel* the scene and sense the drama; this makes him a Romantic artist. Rapid brushstrokes dipped in many different shades are what makes this picture so exciting.

MOROCCO

The Moroccan people looked different to those in Paris in 1832. Women's faces were covered with veils and men wore long robes and turbans. The colourful and exotic customs were like nothing Delacroix had ever seen. The light made all the colours appear more intense. Delacroix was inspired by what he saw.

FUN FACT

• Delacroix's face used to be on the French 100 Franc banknote.

During the journey Delacroix made many drawings and notes about colours he saw in his sketchbooks. He had seen two similar incidents of horses in combat. He painted this picture after he returned to Paris, working from memory and with the help of the drawings in his sketchbook. Delacroix's illustrated *Journal* is one of the most lively diaries in the history of art.

Delacroix wanted to exhibit this picture at the Salon in Paris in 1834. However, pieces were selected by a jury and they rejected this picture. *Why do you think they didn't want to show this picture?* Perhaps they thought it was too brutal and loosely painted.

DELACROIX

Delacroix stayed in Paris for most of his life. He often painted exotic animals at the zoo.

Delacroix didn't like the work of his contemporary, Ingres (page 46). He thought it was too detailed and old fashioned. However, he idolized Rubens (page 52). Why do you think that was?

Delacroix influenced later artists and Picasso admired him so much that he even made copies of some of his paintings.

Signed lower left: Eug. Delacroix

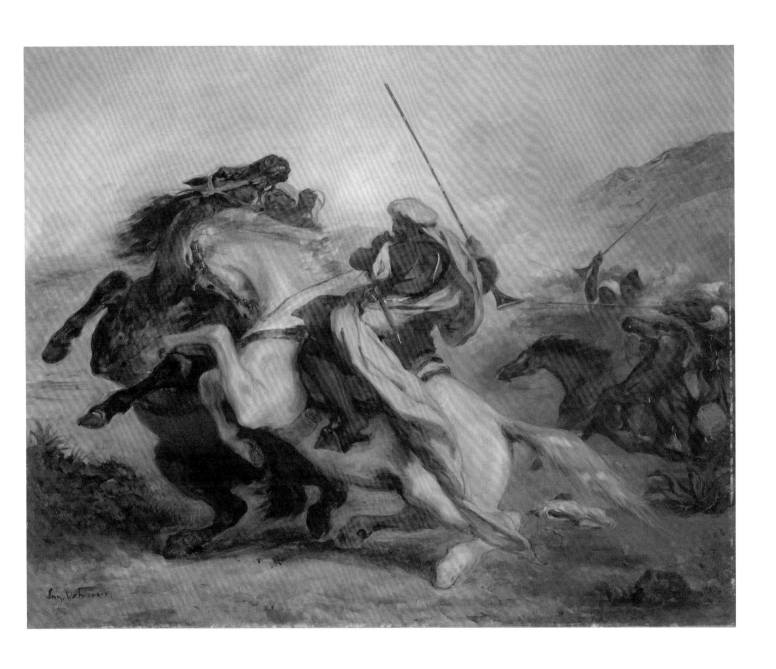

Eugène Delacroix (1798–1863)
Choc de Cavaliers Arabes, 1833–4
Oil on canvas, 81 × 100.5cm (32 × 39½in)
Private Collection

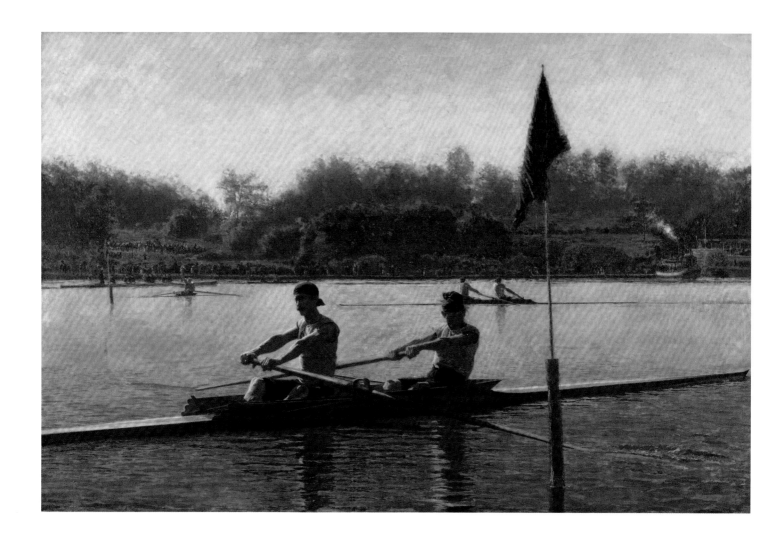

 Thomas Eakins (American, 1844–1916)
The Biglin Brothers Turning the Stake, 1873
Oil on canvas, 101.3 × 151.4cm (39¾ × 59½in)
The Cleveland Museum of Art

THE RACE

Faster! Your muscles are your engines. Every one of them is pumping at full power. Catch the water and then release the oar. Alternate the strokes with your partner while engaging your leg muscles to push back into the seat to get a long stroke. *Will you be the bowman giving the orders?* The bowman sits in the back of the scull boat, closest to the direction of travel. *What do you need to win the race?* Strength, rhythm and focus! If you lose your concentration for a split second it's over!

Have the Biglin brothers turned the stake yet?

FUN FACT

Rowing was a popular sport for educated young Americans after the American Civil War (1861-65). It had been imported to the United States from Britain where it had always been a favourite sport at school and university.

THE DAY OF THE RACE

Imagine: Philadelphia, May 1872. It is a beautiful morning, or is it already afternoon?

Can you hear the spectators cheering for their favourite team?

The rowers, Barney and John Biglin have come from New York to Philadelphia for the race. You are with the painter, Thomas Eakins, on the banks of the Schuylkill River. *Or would you prefer to watch the race from the steamboat?* Eakins knows the best spot on the river as he enjoys rowing himself. He lives in Philadelphia and goes to the regatta every year.

At the midpoint of the race the teams have to turn their sculls around the stake or pole. The stake is marked with the team colours. The Biglin's stake is cobalt blue; their opponent's is red. The turn is tricky as the scull could keel over.

Signed lower left: EAKINS 73

➡ Spot some referee boats in the background! The man in the single scull may be shouting instructions about the best way to take the turn. *Which team is ahead?*

The brothers won the race by one minute and became **world champions**.

HOW THE PAINTING WAS MADE

Do you think Eakins is sitting with his canvas on the riverbank painting the scene as it happens? Would it be possible for him to paint the picture as quickly as the brothers are rowing? In fact Eakins made quick drawings of the scene on the spot and carefully observed the light and reflections in the water. He then painted the canvas in his studio. He had studied the human body in art classes for years. This helped him paint the figures form his studies and memory. In this picture the light emphasizes the arm and knee muscles. ➡ *Can you see their veins popping from the physical strain?*

EAKINS

At the age of twenty-one, **Eakins** went to Paris to study art in the studios of French Realist artists. Like many artists before him, he did the Grand Tour, travelling around the Continent to see the great art of the past. After four years he returned to Philadelphia where he spent the rest of his life.

He painted a famous picture of a man being operated on, appropriately called *The Gross Clinic* (Philadelphia Museum of Art).

ARCHERS

Two young men are out hunting in the English countryside. *Why are they not using guns?* Archery was more elegant and theatrical for Reynolds' painting. *Can you identify the game in the lower left?*

The Irish Lord Sydney on the right is wearing ochre-coloured hunting gear. He is jumping forward and his hair is flying in the air. Colonel Acland in green is leaning back, creating space for us to see Sydney. *What is their target? Who is the older hunter?* ➲ Do you think Sir Joshua Reynolds walked in the woods one beautiful August day in 1769 and painted *The Archers* on the spot? No! He created and dressed a stage for his picture.

SETTING THE STAGE

Reynolds picked the spot, the costumes and the props; everything he needed was in his studio.

> The clearing in the forest is in the shape of a bow.

Reynolds painted the subjects using brushes whilst the forest was done with the palette knife. The tree and the landscape have a thicker texture. The outfits and the elegant silk sashes called for a finer application of paint achieved with a brush. A studio assistant often helped paint the costumes; this saved time and the portraits could be delivered sooner.
How did he paint the sky and the game? Do you think it was with the palette knife or a paintbrush?

THE ARCHERS

Posture says a lot about a person. *What is Reynolds telling us about the two archers?* If you are confident, you stand straight, arms unfolded, shoulders back and speak with authority. Are they weak and helpless men or are they strong and powerful?

Acland fought in the American Revolution and invaded northern New York in 1777, where he was taken prisoner of war. The Americans treated him well. After he returned to Britain someone insulted Americans. He was so upset that he challenged that man to a duel. Luckily no one died.

Acland and Sydney were friends but later they quarrelled about who was to keep the picture. Acland won.

REYNOLDS

Sir Joshua Reynolds was an artist superstar. He made philosophers, aristocrats, actors, authors and scientists look grand and elegant. He was great friends with Dr Samuel Johnson, famous for the quote: 'When a man is tired of London, he is tired of life; for there is in London all that life can afford'.

Every Monday Reynolds met with his intellectual friends at 'The Club' in London where they discussed important matters of the day until the early hours of the morning. If you met the same group of friends every week, what would you talk about?

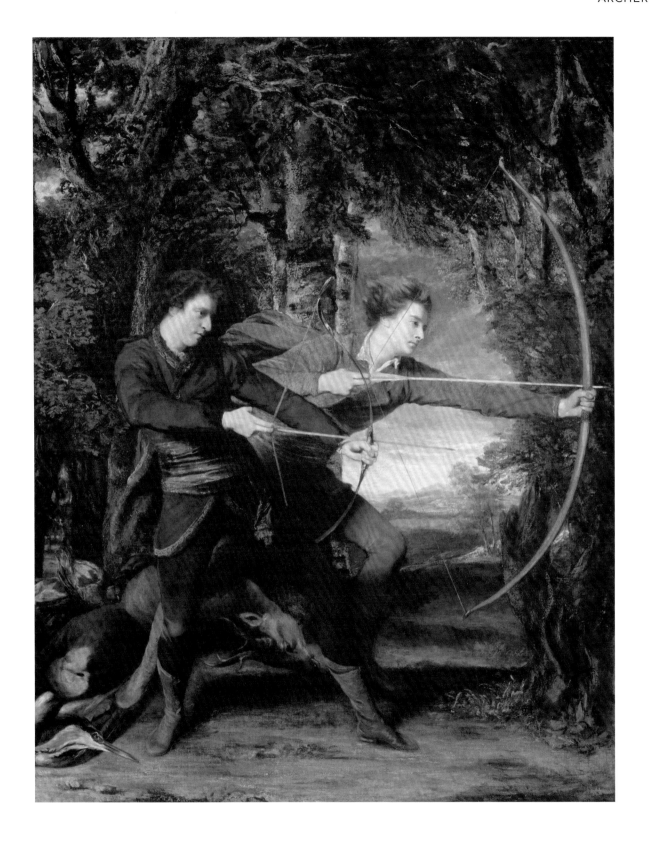

Sir Joshua Reynolds PRA (British, 1723–92)
Colonel Acland and Lord Sydney: The Archers, 1769
Oil on canvas, 236 × 180cm (93 × 70¾in)
Tate Britain, London

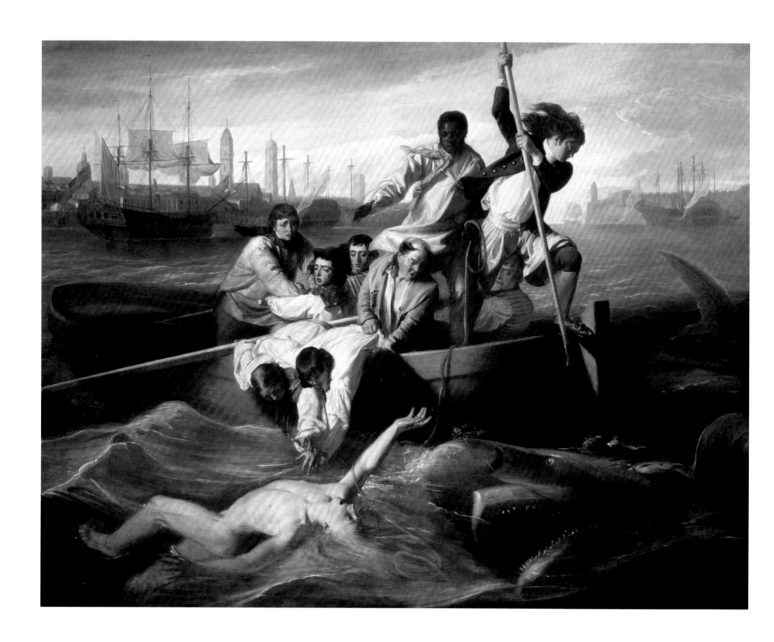

John Singleton Copley (American, 1738–1815)
Watson and the Shark, 1778
Oil on canvas, 182.1 × 229.7cm (71¾ × 90½in)
The National Gallery of Art, Washington D.C.

PG-13

SHARK ATTACK!

It is New Year's Day, 1749, in Havana, Cuba. Fourteen-year-old orphan, Brook Watson has got some time off from his job on the trading ship that belongs to his uncle from Boston. Although the sun is setting beyond the lighthouse it is still unbearably hot so Watson goes for a swim. All of a sudden, a shark attacks! **Help!**

➔ *Can you see the shark's thrashing tail?*

THE RESCUE

Watson's friends and crewmates frantically row the ship's 'jolly boat' to rescue him. *What are they trying to do before the shark pounces again?* Spear the beast with a boat hook? Throw their friend a rope?

An older shipmate holds on to a youngster's shirt so he doesn't fall in. *Is Watson able to grab the rope?* He seems to be in a state of shock. *Has he been bitten?* Watson's right foot is in the bloodied water; Copley spares us the gory details by leaving it to the imagination.

HAPPY EVER AFTER?

Thanks to his shipmates, Watson survived although the shark had bitten off his right foot and his leg had to be amputated below the knee. After three months in the Havana hospital he was able to leave Cuba.

Watson had the inner strength to overcome great emotional and physical pain. He became a successful businessman and politician. At the age of 61 he became Lord Mayor of London. When the king made him a baron, his new coat of arms included Neptune, god of the sea, sitting on top of a shield that featured a severed foot in the design! His motto was *Scuto Divino*, which means 'Under God's Protection'.

ART DETECTIVES

How can you tell that the huge canvas was painted inside Copley's studio?

Twenty-nine years later, Copley painted the event for Watson. Copley imagined the scene after hearing the story from Watson himself. Watson bequeathed the picture to a boarding school for poor children as a moral lesson. *What is that lesson?.*

FUN FACT

- There are 440 species of sharks.
- The shark in the painting is possibly a tiger shark.
- Female tiger sharks are larger than the males. They can measure up to 5 metres (16ft 5in) long and weigh over 635kg (1,400lbs).
- They have stripes on their sides, but not on their heads.
- When a 'sea tiger' senses food, he approaches slowly. This makes it hard to spot him.

COPLEY

Copley grew up poor in colonial Boston. He taught himself to draw by copying European Old Master prints. He then became a hugely successful portrait painter.

During the American Revolution, he and his large family moved to London in 1774. The president of the Royal Academy, Sir Joshua Reynolds (page 60) warmly received the American artist. Visiting the Continent he was finally able to see the great Old Masters that he had known only from prints.

TOURISTS

To complete their education wealthy young men used to travel around Europe on the 'Grand Tour'. They would travel in great style through the Continent to Italy and learn about art. Despite the grey hair, the men in the picture are young. They are just wearing **wigs**, the fashion at the time. They are wearing rich shiny silks and smooth velvets; a few even have fine decorations pinned on their waistcoats. ❯ Look at the shoes; they are all wearing the same style.

On the left the artist Zoffany is presenting a *Madonna* by Raphael. The group in front is discussing a famous nude: Titian's *Venus of Urbino*. The group to the right appears fascinated by the backside of the marble statue called the *Medici Venus*. Perhaps the two groups are arguing which Venus is more beautiful.

ART DETECTIVES

This is not your ordinary museum! *What is unusual about this gallery?* There are only men present. The women in this room are either statues or paintings.

How many corners are in the room? The room is octagonal and it has eight corners although they are not all visible here.

The room is crowded and a bit of a mess. There are many paintings within this painting. Does it remind you of an advent calendar?

HOW IT WAS PAINTED

Can you find the place from where Zoffany painted the scene? The viewpoint suggests that he is standing on a platform, looking down upon the room as we see everything from above and the men appear to be small.

SPOT IT

 ❯ *Can you find all the artist's tools?*
• A palette and palette knife for mixing oil paints
• A maulstick (a stick with a soft tip to support the artist's hand as he paints)
• A painter's easel
• The tools needed to stretch a canvas (a hammer, nails and pliers).
• There are pictures by artists who are featured in this book – see if you can find them by looking at the styles. If you can identify them, your career as an art historian is launched!
Central wall: Rubens' *The Consequences of War.*
Central wall, lower left (below the Rubens): Holbein's *Portrait of Sir Richard Southwell.* Right wall: Rubens' *Four Philosophers.*

FUN FACT

The nude in the centre is the 'Venus of Urbino', 1538 by Titian (Uffizi, Florence). She is probably the most famous nude of all time.

Can you spot the only Egyptian figure in the room?

ZOFFANY

Britain's Queen Charlotte (1744–1818) had never travelled to Italy and she commissioned the German-born **Zoffany** to paint the *Tribuna of the Uffizi* in Florence. This kind of painting is called a Conversation Piece – an informal group portrait – and it was particularly popular in eighteenth-century Britain. It took the artist five years to make this picture. By the time the painting was finished, people thought it old-fashioned. Zoffany left for India in search of more exotic subjects. There he revived his career.

Johann Zoffany (German, 1733–1810)

The Tribuna of the Uffizi, 1772–77
Oil on canvas, 123.5 × 155cm (48½ × 61in)
Royal Collection Trust

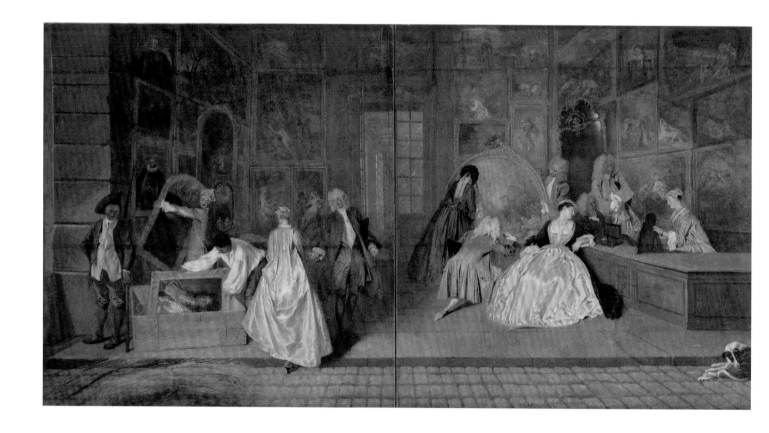

 Jean-Antoine Watteau (French, 1684–1721)
The Shop Sign of Gersaint, 1720
Oil on canvas, 163 × 308cm (64 × 121¼in)
Charlottenburg Castle, Berlin

THE SHOP SIGN

Imagine: you are in Paris and the year is 1720. Welcome to Monsieur Gersaint's fine art gallery. If you are a rich man you need to put on a wig. If you want to be an elegant woman you will have to wear a fashionable silk dress and pin your hair up with a ribbon. Careful, don't trip on the kerb of the cobbled street and try not to fall over the bundle of straw on your left. It will be needed to pack up the purchased pictures.

Will you be a shopper or a shopkeeper?

The woman in pink is glancing at the king's portrait while a gallant gentleman is helping her up the step. Will she buy the portrait of the king who had died five years earlier? *Can you see her stockings?*

Perhaps you are working in the shop. *Would you help pack up Louis XIV's portrait or carry the large mirror?* Can you find some portraits, landscapes, nudes and stories from the Greek myths on the walls.

Do you fit inside the shop?

Where does the glass door in the back of the shop lead? What do you think might be out the back? Can you see the tall windows on the left through the doors.

THE CUSTOMERS

On the right a shopkeeper is showing a large oval picture to a couple. *Are they young?* ➲ *Can you see what the woman is looking at and what fascinates the man?* The man is on his knees peering through a magnifying glass at the nude's knee!

On the far right another group of people is being shown a small picture by a young saleswoman. *Are they transfixed by what they see?* Are you tempted to pull on the shoe peeking out under the woman's striped silk dress?

What are you buying: a painting, a clock, a mirror or a box? Or perhaps you would like to take home the sleeping dog on the right?

ART DETECTIVES

Is the shop crowded? The painting is three metres (10ft) long, roughly the same length as the shop. Is it a sunny day or is it overcast? *Where does the light come from?* Is there a lot of colour in the picture?

FUN FACTS

- The artist took only eight days to paint the picture.
- The picture was displayed as a shop sign for fifteen days. Although the picture was more of an advertisement for Watteau than for Monsieur Gersaint's gallery.
- Gersaint was Watteau's art dealer and his shop was on a bridge. Today there are no longer any shops on the bridges in Paris.
- Originally the canvas was larger and had an arched top but at some point it was cut into a rectangle.
- The paintings on the wall were not displayed in the real shop. Watteau used his imagination.

WATTEAU

Watteau was very self-critical. He thought that his drawings were better than his paintings. Research some of his splendid drawings online and see if you agree or not.

Check out his famous clown *Pierrot* in the Louvre, Paris. His wonderful paintings of outdoor party scenes populated by elegant people can be seen in many museums.

He is a Rococo (late Baroque) master and *The Shop Sign of Gersaint* was his last masterpiece.

THE LETTER

The woman is all dressed up and her hair is elaborately arranged and tied with a yellow scarf. Her dress and the decoration of the room look exotic (in fact they are Turkish). There is mirror nearby so she can check herself one last time before the visitor arrives. *Do you think she looks like this every day? What do you think is happening in the picture?* Can you make up a story to go with the picture?

THE LETTER

A letter has arrived! *Can you spot the red wax seal.* The woman has torn up the letter and thrown it aside on to the carpet.

Do you think the letter contains good news?

Who do you think wrote the letter? Do you think it was the same person she had dressed herself up for? What might she be thinking? What could she be looking at? Do you write many letters to your friends? *When did you last receive a letter?*

ART DETECTIVES

Does the woman live in an elegant or in a simple house? Is it hot or cool in the room?

What kinds of materials are her clothes made of? Can you see the two tiny gold bells on her dress? Notice the black ribbon fastening her pearl necklace.

➔ Spot as many shades of grey and white as you can find.

Identify all the different materials in the room, for example stone, wood, silk, cotton, wool etc. *What is in the basket?*

It is difficult to see where the light comes from, as there is no shadow.

PASTELS
If you have ever used chalk pastels, you will know how difficult it is. If you apply too many layers the colours turn into a brown mush. The benefit of them is you can work fast as there is no need for them to dry.

The woman has been reading. Perhaps it is the tales of Scheherazade, Aladdin, and Ali Baba and the Forty Thieves in *Arabian Nights*. It had been translated from the Arabic into English in 1706.

FUN FACTS

- Liotard's nickname was 'the Turkish painter' because after having lived in Constantinople (Istanbul) from 1738-42 he always dressed in Turkish costume.
- He grew his beard as long as Gandalf the Grey's, the wizard in *The Lord of the Rings*.
- He painted members of the British colony in Constantinople. Muslim women would not allow the artist to paint them unveiled.
- There are three other versions of this work of art and they are all a bit different.

LIOTARD

Liotard was born in Geneva, Switzerland in 1702. He had trained as a painter of miniatures. This taught him to pay attention to the tiniest detail. His work was a realistic representation of his subject.

He loved to travel and paint 'exotic' themes and wanted to mirror nature. He mostly worked in pastels and these are so highly finished they resemble porcelain.

Jean-Étienne Liotard (Swiss, 1702–89)
Woman in Turkish Dress, Seated on a Sofa
Pastel over red chalk under-drawing on parchment, 58.5 × 47.2cm (24 × 20in)
Collection Mrs Charles Wrightsman

 Johannes Vermeer (Dutch, 1632–75)
Mistress and Maid, 1666–67
Oil on canvas, 90.2 × 78.7cm (35½ × 31in)
The Frick Collection, New York

THE SECRET

What is in that letter? The artist Vermeer is not giving us many clues. The dark background is plain and the focus is on the two women exchanging the letter. In those days people sometimes wrote to each other every day. The mail was delivered by hand.

THE MISTRESS

The Mistress has put down the quill; the letter on the table remains half-finished. Does your desk look like this? *How is it different?*
The Mistress's hand is raised to her chin. *Do you think she is surprised?*
What do you think of her yellow silk outfit trimmed with ermine fur and the shimmering pearls? How long would it take the maid to pin her lady's hair up in this fashion? *Do you think she is going to a party later that evening?*

What objects are on the table?

THE MAID

The maid is approaching from behind the table; she is leaning forward politely. *Is she saying something? Would she be permitted to pull up a chair and sit at the table with her mistress?* Her dress with the cobalt blue apron is plain and practical, in stark contrast to the magnificent costume of her mistress. Washing clothes may have made the skin on her arm a bit red.

THE RELATIONSHIP

Do you think the two women in this painting like each other? *Might the mistress of the house share her deepest secrets with her maid?* Does the lady know everything about her maid in return?

HOW THE PAINTING WAS MADE

Vermeer probably laid out the design of his pictures directly on to the prepared canvas in thin oil paint. From there he worked up his picture. First came opaque colours and then some thin glazes on top. At the end he dabbed thicker dots of highlights on the areas that reflect the daylight. *Where does the light come from? Is the table by an open window?*
➜ Look at the highlight on that pearl earring.

FUN FACT

At this time more people could read and write in the Netherlands than in any other country in the world.

TWO GIANTS

Two of the greatest artists of all time lived 64km (40 miles) apart and probably did not know one another. Vermeer lived in the small city of Delft. Rembrandt (page 78) lived in Amsterdam. Rembrandt created 250–300 paintings whereas only about 36–7 works by Vermeer are known today. Both painted similar subjects: household maids as well as the rich citizens of the Netherlands; neither painted royalty. Compare their work. *How do their styles differ?* They were both independent artists and both died poor.

VERMEER

Vermeer painted a number of pictures of women with letters. He frequently used the same costumes and props and probably owned the yellow jacket that can be seen in several of his paintings. No drawings by Vermeer are known.

Vermeer used an optical device called a *camera obscura*. Looking through a *camera obscura* (it does not take photos), allows the artist to focus on the effects of light and colour passing through a lens. Take a look online at his *View of Delft* (the Mauritshuis, The Hague). Vermeer had an unsurpassed ability to create magical pictures of daily life.

WHODUNIT

The stage is set: someone is about to be robbed. It is a game of whodunit. The clues are in the eyes and the hands. Follow them and you will figure out the hoax.

Who is the cheat and who is being cheated? ➡ Look at their eyes; some people seem to have two focal points.

A young maid is serving wine to the woman wearing feathers and pearls. *Is she going to drink the wine or pass it along?* She is pointing to the man on the left. *Is she sending a signal as a way to cheat?*

What is the man on the left hiding behind his back? ➡ Can you spot his pile of coins?

There is one person who can look at everyone's cards without being noticed. *Who is it?*

No one is speaking. By sending secret signals to each other, they are cheating.

ART DETECTIVES
Georges de La Tour is sending us a coded message in both paintings – what do you think it is?

THE FORTUNE TELLER
What is happening to the elegant young man who is having his fortune told by an old gypsy on the right? He is sandwiched between four women. The pretty one is snipping something off with clippers. What is it? Why are her eyes fixed on the man? What are the women doing on the left? The woman with dark hair at the back, is ready to receive something in her hand. *Does the fool notice anything or is he so eager to know his fortune that he is about to lose one?*

LA TOUR

Georges de La Tour lived in a small French town and painted such wonderful pictures that the king of France made him his first painter. De La Tour paints in a style called Baroque, where artists often tell a dramatic story. The colours are rich and there are sharp contrasts between light and dark. Georges de La Tour was forgotten for about 200 years after his death. Now people love his paintings again for the exciting stories and the warm colours that he used. The background in his paintings is always simple and plain. He built up the paint with careful brushstrokes and applied glazes for luminosity and highlights at the end. He greatly admired Caravaggio (see page 82).

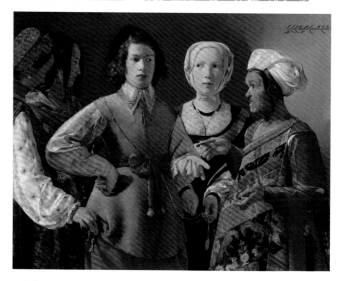

The Fortune Teller, probably 1630s
Oil on canvas
101.9 × 123.5cm (40 × 48½in)
The Metropolitan Museum of Art, New York

Signed

and inscribed: (upper right)
G. de La Tour Fecit Luneuilla
Lothar: (Lunéville Lorraine);
(on young man's watch
chain) AMOR (love) FIDES (faith)

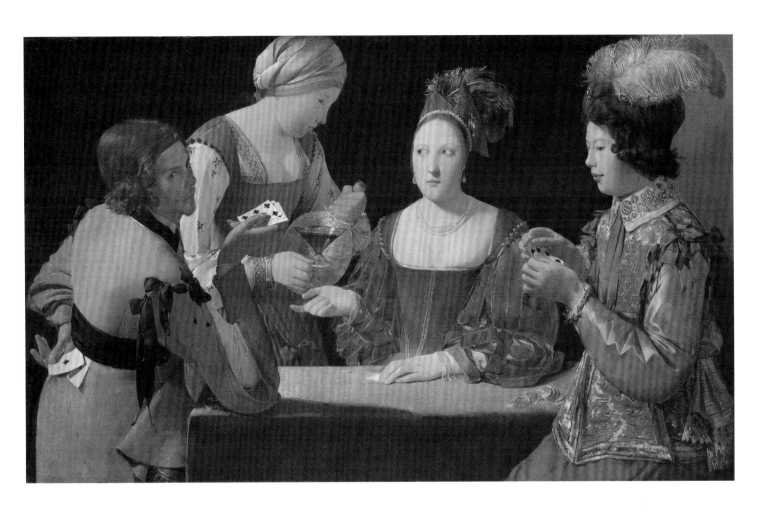

Georges de La Tour (French, 1593–1652)
The Cheat with the Ace of Clubs, c.1630–34
Oil on canvas, 97.8 × 156.2cm (38¼ × 61½in)
Kimbell Art Museum, Fort Worth, Texas

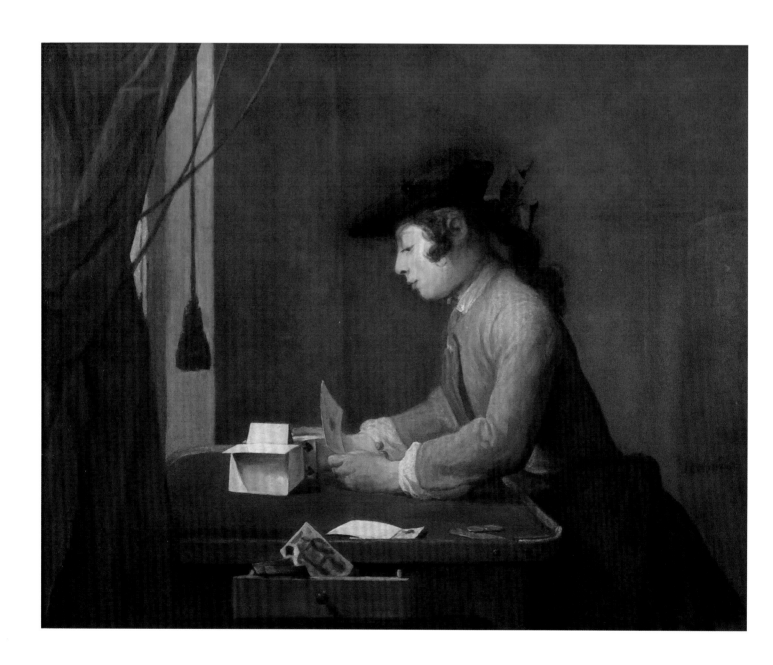

 Jean-Baptiste-Siméon Chardin (French, 1699–1779)
Boy Building a House of Cards, 1735
Oil on canvas, 81 × 101cm (32 × 44in)
Waddesdon, The Rothschild Collection (Rothschild Family Trust)

HOUSE OF CARDS

In the eighteenth century a boy might try building a house of cards instead of using Lego. *What do you think would be the best surface for your house of cards, felt or polished wood?* Gaming tables frequently have felt tops. *Would you use a new deck of cards or an old one with soft, worn edges?*

➲ See what's on the table – can you find some coins, a tally for keeping score and a red gaming chip? *Does the boy need all those things?*

Do you think someone was playing at the table before the boy got there?

In the eighteenth century boys wore hair long, tied back with silk ribbons.

How old is this boy and why is he wearing an apron? Do you think the boy works in the house and was sent to clean up? *Perhaps he opened the red curtain and then was tempted by the cards? Do you ever get distracted?* The boy is so focused on the cards now that he does not notice anything else. If you were the boy, where would you place the ace of hearts? What does the heart on a Valentine's card represent?

FUN FACT

Playing cards originated in China in the ninth century. The oldest full deck of cards is believed to date from the fifteenth century and is in the Metropolitan Museum of Art, NY.

ART DETECTIVES

What is Chardin telling us?
Clue: is a house of cards a sturdy structure?
Life can be fragile like a house of cards. If one isn't paying attention, things can change in a split second and everything collapses. Chardin paints a child because he is he telling us that time passes quickly and before you know it you will be an adult.

Signed centre right
J.B. Chardin

Chardin was a master at painting still lifes. Which part of this picture would you call a still life? He greatly admired the great Dutch seventeenth-century 'genre pictures' by Vermeer (see page 70) and Rembrandt (see page 78) with their hidden messages and scenes of everyday life.

Does Chardin use a lot of vibrant colours in this picture?

Chardin painted four different pictures of boys building a house of cards. You can look at the other three online to see how each one is quite different:
National Gallery of Art, Washington DC (www.nga.gov), **Musée du Louvre**, Paris (www.louvre.fr), **National Gallery**, London (www.nationalgallery.org.uk)

CHARDIN

Chardin took months to compose a painting. He painstakingly placed every object only to move everything around again. Can you see the 'ghost' or *pentimenti* of a screen on the right? Although Chardin painted it out you can still see the outline coming through.

Chardin lived and worked in the Louvre, Paris. He said he painted with feelings and used colours as a tool. He liked to paint everyday subjects. He was inspired by the Dutch Golden Age painters such as Vermeer, Rembrandt and Hals.

TEMPTATION

This painting illustrates the New Testament story of the devil luring Christ to the top of the mountain to show him all the beautiful kingdoms of the world. He offered Christ all the kingdoms with one condition: Christ would have to worship the **devil**. Christ turned to the devil and sent him packing and at that moment, the angels appeared.

Which figures are good and which are evil in the painting?

SCALE

Why do you think the figures are so much bigger than the cities? Perhaps Duccio wanted to highlight Christ's triumph over the devil.

If you are too young to visit the Frick in New York, a few blocks north you can admire a small Madonna and Child by Duccio at the Metropolitan Museum of Art.

LA MAESTÀ

On the 9th of June 1311 an enormous altarpiece called *La Maestà* (The Majesty) was carried from Duccio's studio to the cathedral in Siena, Italy. The front of the altarpiece depicted the Madonna and Child surrounded by the apostles, angels and saints. The back showed scenes from the life of Christ including this picture of the devil tempting Christ.

The altarpiece is made up of many smaller panels set into a large piece of wood. The Siennese would mostly see the altar from afar, but when they approached the altar they would be able to see and understand the stories on the smaller panels, like this one. In medieval times, very few people could read. Images like this served an important purpose – they were how people learned as well as being visually pleasing.

THE CHARACTERS

What do you think of the devil? ➍ Take a look at his ears, his feet and the scary expression on his face! *How would you describe Christ's face: gentle or stern, kind or strict?*

See the thin line of pure gold running along the edges of Christ's cloak? From a distance it draws the eye along the flowing material. The gold leaf illuminates the background making it glow in the candlelit church. Duccio cut the pattern of the halo with a metal stylus while the prepared ground on the panel was still soft. (See how Klimt (page 48) used gold leaf.)

The kingdoms of the world are tiny as if made of Lego. *In which castle would you like to live?* You may want to avoid the dark one by the devil's knee!

FUN FACTS

- It took Duccio three years to complete the altarpiece.
- This painting is over 700 years old but it looks as if it might have been painted yesterday.
- 300 years ago the altar was cut apart in order to create two separate altars.

DUCCIO

Little is known about the life of this early Renaissance master. Duccio's method of placing figures in a landscape with architecture was new at that time. He gives his figures a rounded shape and emphasizes light and dark areas.

Duccio is considered one of the founders of Western art.

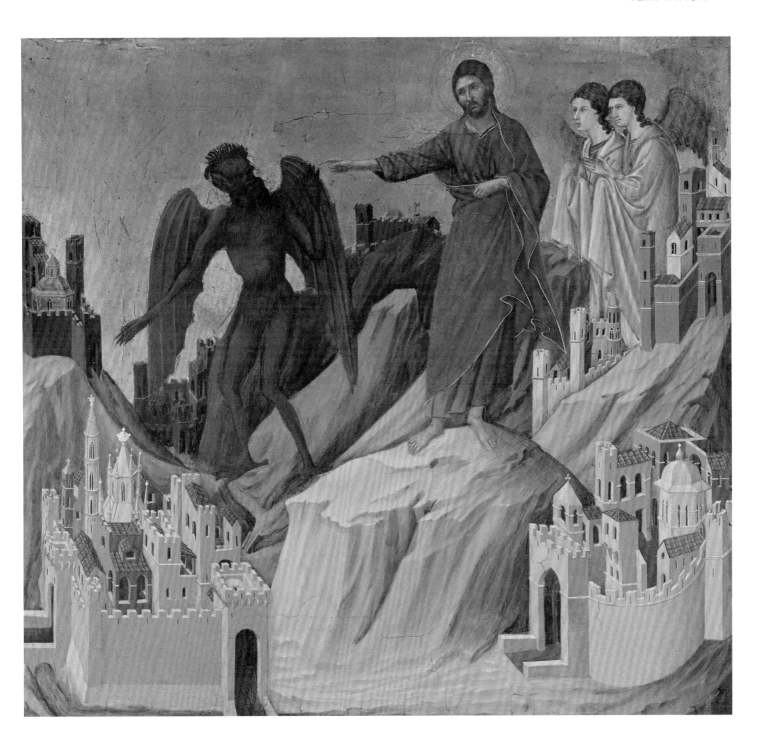

Duccio di Buoninsegna (Italian, c.1255/60–1318/19)
The Temptation of the Christ on the Mountain, 1308–11
Tempera on poplar panel, 43.2 × 46cm (17 × 18¼in)
The Frick Collection, New York

77

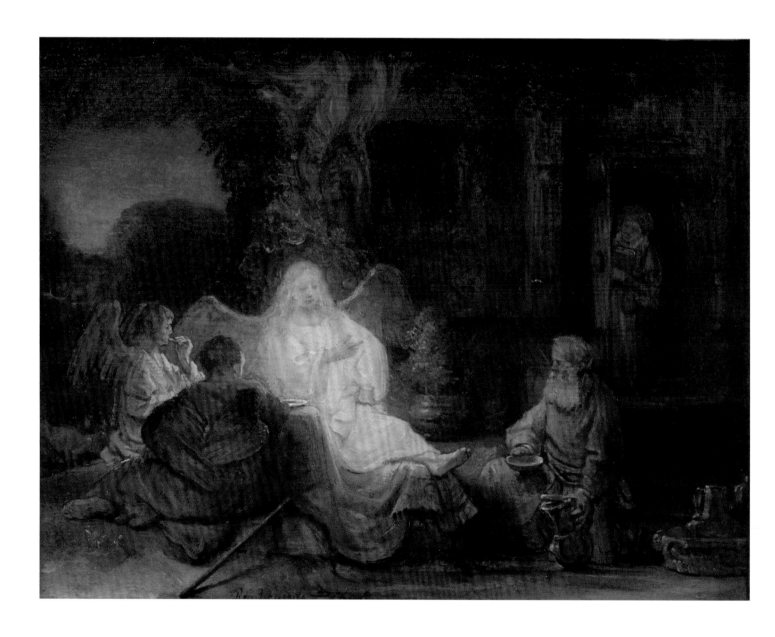

 Rembrandt van Rijn (Dutch, 1606–69)
Abraham Serving the Angels, 1646
Oil on panel, 16 × 21cm (6¼ × 8¼in)
Private Collection

GUESS WHO'S COMING TO DINNER?

Imagine: you are standing in front of the house of Abraham, from the Old Testament. *Is it a humble or a grand house?* Abraham has invited an unusual looking group of people to dinner. They are resting under a gnarly old tree. ➡ *Can you find Abraham's wife Sarah who is eavesdropping on their guests?* What are they talking about?

THE GUESTS

Who are these guests and why do they have wings? The angel nearest to us with the red tunic has gently folded his wings. The one on the left has started eating his dinner. The figure in the centre with the long blonde hair has spread his wings. Abraham is about to wash his guests' feet. *Why would he do that, when they arrived flying on their wings?* At that time a host would wash guests' feet as an act of politeness and humility.

If you touched the wings how would they feel? From what species of bird might the feathers be? ➡ Spot the potted plants by the house!

THE NEWS

The angel in the centre is pointing towards Sarah who is standing behind the door. He is telling the elderly Abraham that his wife Sarah is going to have a baby. Sarah laughs; she is in her nineties and has never had a child. *Do you know many people in their nineties who have babies?* However, Sarah and Abraham did have a son and they named him Isaac. Sarah reputedly lived to the age of 127.

THE LIGHT

Rembrandt is known for painting light. *In this painting is it dawn or dusk?* What light is shining on the group; is it sunlight, moonlight, fire or another light source?

A warm glow radiates from the angel in the centre. *How many colours can you see in the painting?*

EMOTION

After seeing this picture you will recognize Rembrandt's work in museums. He conveys how people feel and shows us their character. He captures the mood of a scene without the use of a lot of colour. Many of his pictures are bathed in a distinctive golden glow.

PRINTMAKER

Rembrandt was also an accomplished printmaker. He did many etchings – drawings etched in metal which could be printed multiple times. These could be easily circulated and accounted for his international fame.

REMBRANDT

Rembrandt was one of the greatest artists who ever lived. In this small picture he captures a complex moment in which a lot is going on.

Rembrandt never left his native Netherlands. He did, however, keep a close eye on those artists who returned from studying in Italy. Rembrandt and his family lived in a big house in the Jewish quarters in Amsterdam where he frequently painted members of the community. He painted himself many times, which allowed him to study different moods.

He was a spendthrift and bought a lot of art for his own collection. Although he was very successful he could not manage money and ended up living in poverty in his old age. Like Vermeer, (page 70), Rubens (page 52) and Velázquez (page 34), he was a giant of the Golden Age of Dutch painting.

Signed and dated 1646 lower centre

THE QUEEN OF HEAVEN

High foreheads used to be a sign of beauty. *Would you shave your hairline to create the impression of a high forehead?* The Queen of Heaven is the Madonna with the baby Jesus. Jesus seems to be floating. He is not drinking his mother's milk but is pointing to the left.

THE ANGELS

There are two types of angels here. The blue cherubim guard the heavenly throne. We don't see the bodies of the chubby cherubs; only one little foot is peeking out on the right edge. The red seraphim carry the throne. *Can you count how many of each are visible?*

ART DETECTIVES

➔ Can you spot the reflection of Fouquet's studio window on the two balls of the throne?
What are the three main colours in the picture?

Fouquet paints these angels in 'burning' red, the colour of love

FUN FACTS

- In medieval times blue was the symbol of heaven.
- 'Seraphim' means 'the burning ones' in Hebrew.
- Seraphim are normally shown with six wings: two for flight, two for covering their feet and two for shielding their eyes.

THE QUEEN OF HEAVEN

The Madonna is dressed like a queen and she wears a crown. Can you name the jewels? *Do you think that the tassels of the throne are made of real gold thread?*
Her white silk coronation robe is lined with rich ermine fur with its recognizable dark tail-tips.
Does the skin of the figures resemble white marble or real skin? Does the Virgin look

like a real person or did Fouquet invent her features? The model for the Virgin was called Agnes Sorel. They say Agnes was the most beautiful woman in the world. She was a close friend of King Charles VII of France. *How does Fouquet manage to make that gauze veil look so transparent?*

PORTABLE ALTAR

This painting makes up the right half of a diptych. A diptych (from the Greek word for the number two) is a personal, portable altar. It is made of two hinged panels of equal size that can be folded shut to protect the paintings. You can look up the left half of this one online. It is called the *The Melun Diptych*, (Gemäldegalerie, Berlin). *Do you think they look good together?*

FOUQUET

Fouquet painted in oil and also illustrated beautiful books. He worked for King Charles VII of France. Charles had become king with the aid of Joan of Arc at the end of a war that lasted one hundred years. The king had a wife, but his true love was Agnes. By the time Fouquet painted the picture, Agnes had died, but her beauty was unforgettable.

Fouquet had travelled to Italy to see the art of the great Italian masters. He also admired Jan van Eyck (see page 100) who was a bit older. His style of painting represents the transition between the Late Gothic and Early Renaissance.

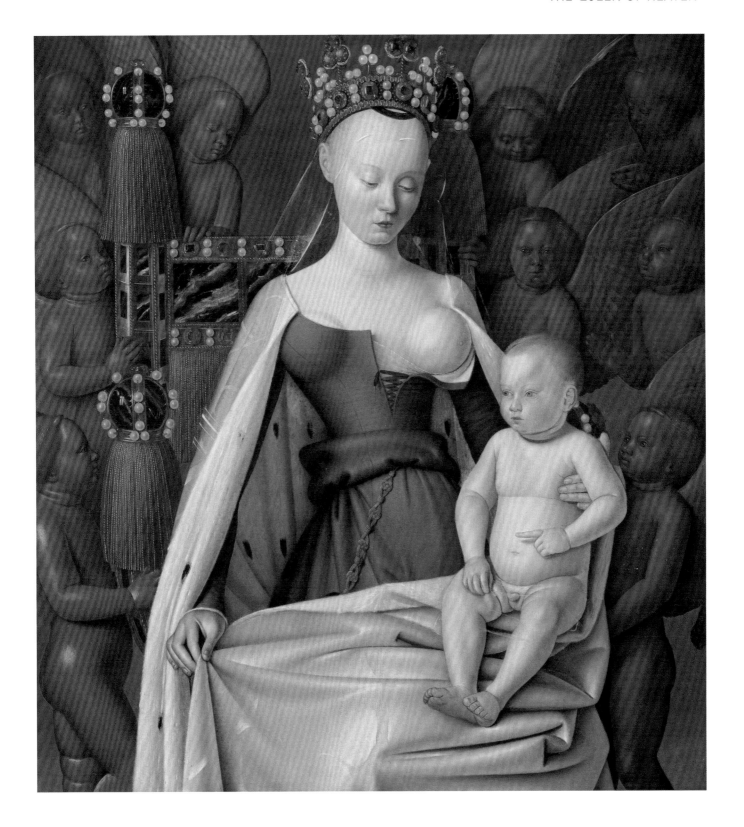

Jean Fouquet (French, c.1420–81)
Madonna and Child Surrounded by Cherubim and Seraphim, c.1452
Oil on panel, 94.5 × 85.5cm (37¼ × 33½in)
Royal Museum of Fine Arts Antwerp

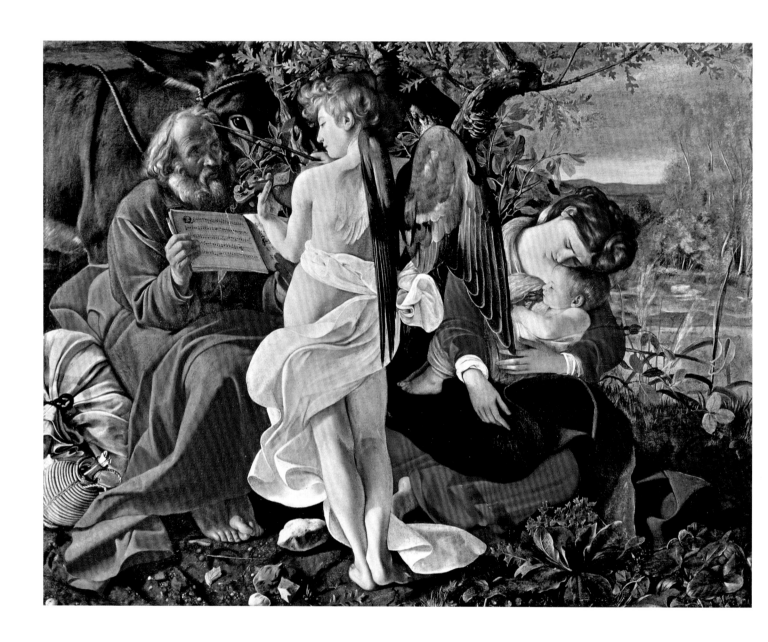

 Michelangelo Merisi Da Caravaggio (Italian, 1571–1610)
Rest on the Flight into Egypt, c.1595
Oil on canvas, 135.5 × 166.5cm (53¼ × 65½in)
The Doria Pamphilj Collection, Rome

HOW BEAUTIFUL YOU ARE

The Holy Family is fleeing from danger. The donkey with the kind, watchful eye is carrying them on their 323km/200 mile-long journey from Bethlehem to safety in Egypt. They have stopped for rest and water. ➲ *Can you see the stream where Joseph can refill his water jug?* They are poor. Joseph is holding the sheet of music for the angel. *Have Mary and the baby Jesus nodded off?*

THE ANGEL

How old is the angel? Do you think his sash is about to fall down? The wings are huge; what kind of bird would have such a wide wingspan? The angel is playing a violin. *Can you hear the music?* In Latin the piece is called: *Quam pulchra es* ('How beautiful you are')

HOW DID HE PAINT IT?

Caravaggio created this picture over 400 years ago. We do not know a lot about his working methods except that he painted quickly and directly on to the canvas. He would have swiftly sketched the outlines of each model and then painted the figures, one by one. *Do you think he sat in the woods to paint the scene?* He probably painted it in a cellar or a tavern in Rome.

Caravaggio died young and had completed about 80 paintings.

LIGHT AND DARK

Caravaggio was interested in the sharp contrasts of bright light casting dark shadows. This is called chiaroscuro, which means light/dark in Italian. *Which direction is the light coming from in the picture?*

Experiment with creating your own chiaroscuro scene. Close the curtains and leave open a small crack for the sunlight. Place a favourite toy in the ray of light. The background will look very dark. These contrasts will make the scene look quite dramatic. Look for the big light or dark shapes.

FUN FACT

Caravaggio used real people to model for him and then turned them into the Holy Family and saints. He picked working men and women from the streets.

THE MODELS

Joseph's face is weathered. *Does he look like a man who does manual labour? Are his hands smooth or rough?* Perhaps the sitter for Joseph was a street cleaner and the model for the Virgin Mary might have been a pretty waitress from the tavern.

CARAVAGGIO

The 'most famous painter in Rome', Caravaggio had a difficult childhood. Most of his family died in the plague when he was six years old. Born in Milan, he moved to Rome when he was twenty-one where he quickly became famous. He painted for the Church. At first he always painted directly from the model. Later, after 1603–5, he sometimes painted from his imagination.

He was a complex character; his bright side was his art but his dark side was his temper. He was jailed several times and even killed someone in a sword fight. He died, aged thirty-eight, from his wounds while on the run from the law.

TRAINSPOTTING

Can you hear the thundering train approaching? Can you see it? Is it blowing off steam? *Are we interrupting the woman from her reading?* The puppy is sound asleep in her lap and does not seem to mind the noise. The girl is too interested in trains to turn around to notice us.

WHERE ARE WE?

We are in the backyard of a house that belonged to a friend of the artist. Manet used to make sketches on the spot and then painted large canvases in his studio. You can see the windows of Manet's studio in the upper left corner of the painting.

Can you spot her snack?

Look closely and you will see the raw canvas in some areas.

ART DETECTIVES

What feels unusual in this picture? Are we standing close to the woman and the child? *Is the woman shy and demure?* She is looking at us, in a direct way. Is she saying, 'Move on, you are interrupting my reading'? Notice her finger holding the page in her book, as if she is waiting for us to leave. The woman is self-assured and dressed in the latest fashion. The girl appears independent. *Would you like to explore Paris with her?*

➡ On the right you can spot the stone pillars of the *Pont de l'Europe*, a groundbreaking cast-iron bridge that spans the railway tracks.

WHO ARE THEY?

Do you think the woman and the child are related? The woman's name is Victorine Meurent and she was Manet's favourite model. Look for her in *Olympia* and *Le Déjeuner sur l'herbe* (Musée d'Orsay). The girl is the daughter of a friend of Manet's. She and Victorine were not related.

Signed and dated lower right
Manet 1873

HOW IS IT PAINTED?

Are the lines sharp and are there defined contrasts? *Is the light bright or soft?* Although Manet's Impressionist friends used soft edges, blending the colours and were unconcerned with details, Manet preferred sharp contrasts and distinct light and dark areas, just like the Old Masters. He applied quick, single brushstrokes to the canvas. *Do you think he used a broad brush or lots of little ones?* If he did not like something he had done, he wiped the wet paint off with a cloth.

A NEW AGE

Why is this picture considered 'modern'? This was the Industrial Age and steam trains were the latest way to travel (see Ingres page 47). Trains represented all that was new and were popular subjects for artists of the time. Claude Monet (1840–1926) also painted Gare Saint-Lazare several times. Monet sat inside the railway station at different times of the day and painted it with varying light effects.

MANET

Édouard Manet was born in Paris. His parents disapproved of him becoming an artist – they wanted him to be a lawyer or enter another 'respectable' profession. Manet was friends with the Impressionists but although they influenced each other's work he did not want to exhibit with them.

Manet greatly admired the Spanish painter, Velázquez (see page 34).

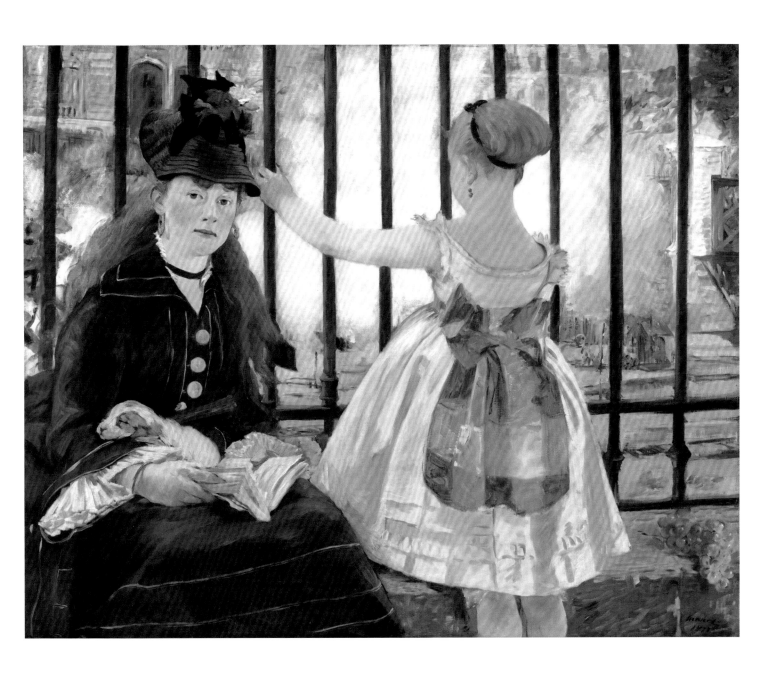

<u>Édouard Manet (French, 1832–83)</u>

The Railway, 1873
Oil on canvas, 93 × 112cm (36¾ × 45½in)
National Gallery of Art, Washington D.C.

 Joseph Wright of Derby (British, 1734–97)

An Experiment on a Bird in the Air Pump, 1768
Oil on canvas, 183 × 244cm (72 × 96in)
The National Gallery, London

THE EXPERIMENT

Imagine: you are in a house in the British countryside. A travelling scientist is visiting to demonstrate a scientific experiment. Everyone is crowding around the table to watch. ➲ *Can you pick out the scientist?* Does he remind you of a wizard? *What is the scientist holding in his hand?* He is holding up a glass flask that contains a bird. *What kind of bird is in the flask?* (The answer is on the right.)

The experiment consists of pumping the air out of the flask to find out how long the bird can survive without oxygen. *Do you think the bird will make it?* Don't worry; the scientist won't want to harm the bird. Exotic birds were valuable at that time and he will need it when he travels to the next house to demonstrate the same experiment.

THE AUDIENCE

Who is concerned about the bird? A man is consoling the two girls who seem upset.

Is everyone paying attention to the experiment? Two people seem to be in love and not interested in science at all. Only two people are actually observing the bird's movements. *Which are they?*

ART DETECTIVES

➲ Look out the window, what phase of the moon is it? It is a full moon. *What is the weather like?*

THE PICTURE

Do you think the light of the candle and the moon adds drama to the painting? *Would the picture be as mysterious if depicted in broad daylight?*

Who would you like to be in the picture?

FUN FACTS

• Cockatiels are very sociable and get depressed if they are kept alone.
• A cockatiel can live 15-25 years compared to a cockatoo which can live 40-60 years or longer.

What do you think is in the glass jar on the table? *Can you spot the birdcage?*

See if you can identify some of the instruments on the table.

Can you work out what the family's status is from the painting? *What clues can you find that might suggest they are a well-to-do family?*

THE BIRD

The bird in the picture had always been called a cockatoo until a nine-year old bird lover correctly identified the bird as a cockatiel. *How did he tell?* Firstly, a cockatoo's crest is located at the back of the head whilst the cockatiel's is at the front. Secondly, a cockatoo would be too large for the flask.

WRIGHT OF DERBY

Joseph Wright of Derby liked to paint the chiaroscuro effects of light and dark at night. After he painted this picture he travelled to Italy. In Naples he painted many moonlit pictures of Mount Vesuvius erupting (although he never actually witnessed an eruption).

The eighteenth century was the Age of Enlightenment. Revolutions of thought, philosophy, science, society and politics were changing the traditional world. Wright of Derby was interested in both art and in science

He regularly met with a group called the Lunar Society to discuss all the latest discoveries. *Luna* means moon in Latin. The men always met during the full moon and sometimes Benjamin Franklin, one of the Founding Fathers of the United States, attended.

THE PHILOSPHER'S STONE

Once you cross the threshold of this laboratory you will become an alchemist! Your task is to find the legendary Philosopher's Stone that can transform plain metal into precious gold. Have a look and see what your assistants are doing. You may want to instruct them to use different tools and liquids.

THE LABORATORY

Find a hammer, tongs and some bottles on the ledge. Some of your tools may need sharpening on the grinding wheel. ➡ *Can you see it?* The fire is going out. Pull on the chain of the large bellows to keep the fire going for a while.

Make sure that your dog has enough food and water. *Is he looking guilty because he chewed on the little white pipe that is on the floor?*

➡ Find some books on alchemy.

➡ Ask the man who looks like a wizard to help you mix up some magic potions to find the Elixir of Life. This **magic potion** would let us live forever. Everyone wants to stay youthful. Finding it would be as good as finding gold. Did anyone ever find it?

How much time have you got to finish your work? Check the hourglass on the table. *Is that garlic or magic powder wrapped in paper on the table?* Alchemy seems to be a rather 'fishy' business. *Can you spot the two fish in the lab, one is carved in wood and the other is hanging from the ceiling.*

There are some triangular clay containers scattered all over the floor. They are called crucibles and are used for smelting (melting) metals.

Look at the small animal skulls hanging on the wall. *Any idea what animals they might be?* Can you see the tally sticks chalked on the wall? *How many times can you count?*

Is this picture colourful? Name as many colours as you can see.

Signed lower right
D. Teniers. F.

FUN FACTS

● Copper, lead, iron and tin were the common metals alchemists tried to convert into gold.
● Although they failed, the search for the mythical Philosopher's Stone led to knowledge that would eventually be developed into the sciences we know today.

ART DETECTIVES

Can you tell what time of the day it is? What season is it? The room seems quiet and is bathed in warm light. The trees have green leaves.

TENIERS

Born in Antwerp **David Teniers** came from an illustrious family of Flemish painters. His father, son and grandson were painters as well. His wife was the daughter of Jan Brueghel (1568–1625) and the granddaughter of Pieter Brueghel the Elder (1525–69), see page 98.

In the mid-seventeenth century people were obsessed with alchemy and Teniers was fascinated by the subject and painted it many times. Perhaps he thought by painting alchemists he could spy on their secrets and become rich.

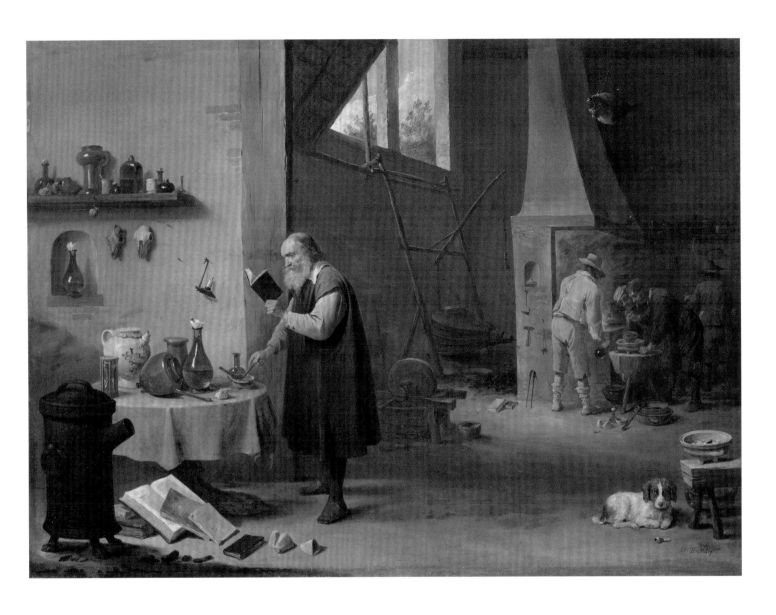

David Teniers the Younger (Flemish, 1610–90)
The Alchemist
Oil on canvas, 48.5 × 66.5cm (20 × 26½in)
Collection Prince zu Salm-Salm, Anholt

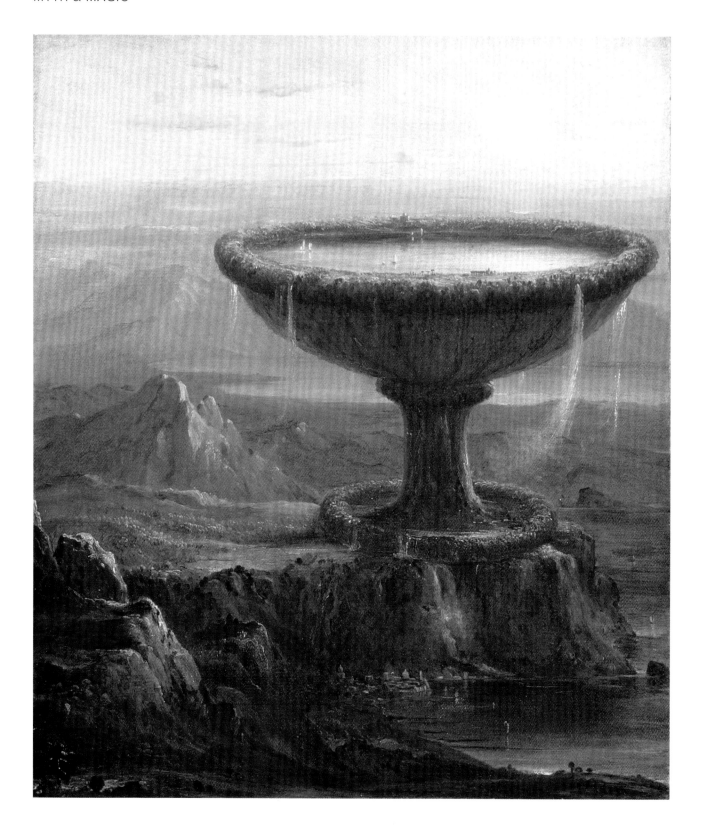

 Thomas Cole (American, 1801–48)
The Titan's Goblet, 1833
Oil on canvas, 49.2 × 41cm (19¾ × 16¼in)
Metropolitan Museum of Art, New York

TITAN'S GOBLET

Titans are powerful giants from the Greek and Roman myths. They were deities (gods) that symbolized various aspects of nature. **Gaia** is a female Titan who represents Earth. **Aether** is male deity. He symbolizes the 'Upper Air' that only the gods can breathe. Pick your Titan!

Imagine: you are a thirsty Titan and are looming large over a beautiful dream-like landscape. *Are you standing on a mountain cliff? Does the goblet look huge or tiny for your giant size? What is it made of?* Would you be able to lift the stone goblet with one hand? *Water is spilling over the rim. Is the rim smooth or covered in moss?* Careful, if you take a sip you may choke on something hidden in the water. ➡ *Can you identify what is on the rim and on the surface of the water?* Spot a tiny city nestled in the rock beneath the goblet.

ART DETECTIVES

Is this a real scene or is it a fantasy?
What do you think inspired this landscape? **Clue:** Can you spot a Greek temple and a Roman villa.
The boats look modern. They could be floating on the River Thames or the Hudson River today.
The buildings are from ancient times and the landscape is from the Hudson River with a dash of romantic freedom!
Is the sun rising or is it setting?
➡ Look through the book to compare this with works by other artists who were also interested in nature and light!
Which of the following were important to Cole?

People

Landscapes

Reality

Ancient stories

Three answers out of four are correct!

 Signed lower right: T Cole/1833

FUN FACT

Titan is also the name of largest moon of the planet Saturn and the second largest moon in the solar system.

THE HUDSON RIVER

Cole's home was in the Catskill Mountains in New York State (and you can still visit today). *Have you ever seen photos of the foliage changing colour in the autumn in New York State?* There are a huge range of colours: oranges, yellows, ruby-reds, purples, greens and browns. Cole was the founder of the 'Hudson River School' of painting.

Looking at this painting our vantage point is that of the Titan standing on a hill across the goblet. *Do you think Cole is a titan of American art?*

COLE

<u>Cole</u> was born in Britain and moved to America as a teenager. In 1829 he sailed for Europe and his first stop was London. There, the 28-year-old Cole met Turner, aged 54 and Constable, aged 53 (see pages 106 and 24). They were the titans of British landscape painting. What do you think they talked about? Do you think the discussions about their art were lively?

After London, Cole travelled to Italy to see the Old Masters. In Rome, he visited churches, ruins and ancient temples. Three years later he returned to America and full of inspiration from his journey, he painted *The Titan's Goblet*.

CASTING A SPELL

The Greek myths tell us that Orpheus has the power to charm not only all living beings with his music but even stones. Apollo, the god of music, gave Orpheus a **golden lyre**. ➡ Take a close look at Orpheus' instrument in the painting: *is it a lyre?* Cuyp chose to paint Orpheus with a violin, an instrument the Dutch were perhaps more familiar with in Dordrecht in 1640.

Did these animals live in the Netherlands in 1640? How is it possible that predators and prey are not attacking each other? They are transfixed by Orpheus' enchanting tune. ➡ Be careful not to startle the jaguars they may lash out if we make too much noise. *Are they staring at us so we will be quiet and listen?*

What kind of song would cast a spell on you?

Split the animals into domestic and exotic animals. *How many are there and can you name them all?* Don't forget the owl! Which is your favourite animal in the painting? Do you think the animals joined in with the music-making? What animals communicate with sounds? If you had an orchestra of animals, which animals would you want as members?

FUN FACT

Cuyp would not have been able to paint the more exotic animals from life. In fact he probably copied the jaguars from a print. Do you think they look a bit two-dimensional compared to the horse for example? For some of the smaller animals he may have used stuffed specimens for inspiration.

Signed lower right: A.cuyp

ART DETECTIVES

Do you think this picture was painted in Greece or in the Low Countries?
➡ Take a look at the light and the afternoon sky. Does it have the white light of the Mediterranean or the softness of the northern sky?

THE MAGIC OF MUSIC

Does music change your mood? Music affects animals as well as humans. Cows produce more milk when listening to slow classical music. Horses perform dressage (see page 35) by moving rhythmically to music and some monkeys stick their tongues out when they find certain music distressing! Dogs will sleep to Mozart and bark at Heavy Metal. The ancient Greeks were clearly observant when they wrote about Orpheus' ability to charm animals with music!

CUYP

Everyone in **Cuyp**'s family made art and he learned to paint from his father. He loved the landscapes of his home with the big sky, low horizon lines and soft light. Cuyp never travelled to Asia or Africa. Elephants, jaguars and camels did not exist in the Netherlands but the Dutch were rich merchants trading goods all over the world. They collected wondrous things like fossils, minerals, precious stones, tusks and stuffed exotic animals to display at home. Cuyp would have seen stuffed exotic animals in collectors' 'cabinet of curiosities'.

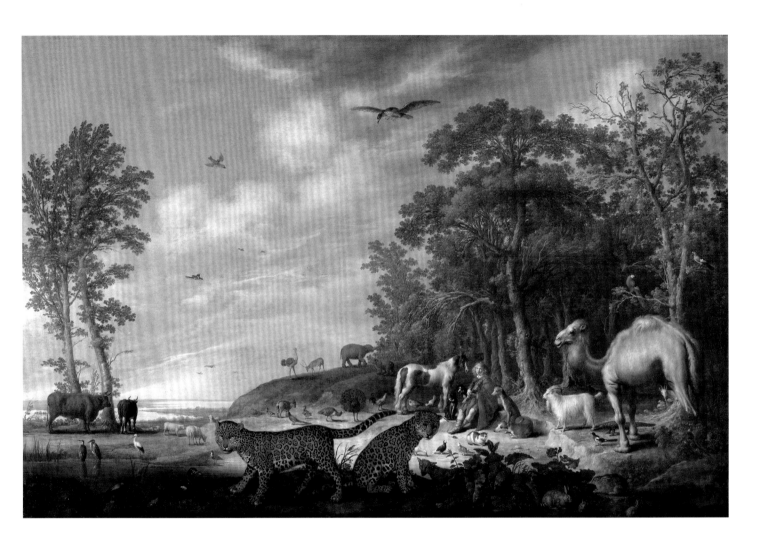

Albert Cuyp (Dutch, 1620–91)
*Orpheus Charming the Animals, c.*1640
Oil on canvas, 113 × 167cm (44½ × 65¾in)
Rose-Marie and Eijk van Otterloo Collection

SPOOKY HEAD

Step back and what do you see? *Is this is a typical portrait of a king wearing a crown?* Look closely to see what is unusual. Each element is made up of a animal. The crown is composed of different antlers. A ram's fleece is hanging like a pendant from the necklace. This is a reference to the Hapsburg Emperors who bestowed an order on their bravest knights. It was called the 'Order of the Golden Fleece' after the story of Jason and the Golden Fleece from the Greek myths. This picture is one of a set of four, each representing one of the four elements: earth, air, fire and water.

> Each piece is made up of a different animal and they fit together like a jigsaw puzzle.

ART DETECTIVES

Can you identify the animals and what they all have in common? Which element does this painting represent? *Earth* is made up of mammals.

THE HIDDEN MESSAGE

Arcimboldo painted *Earth* for the Holy Roman Emperor Maximilian II (1527–76). The emperor was fond of animals and science, but there is a hidden message in this puzzle. ➲ *Can you figure out what it is?*

The message is power: the emperor has a lot of **power** – so much that he even rules over the four elements. Do you think this message might have intimidated people who saw the picture?

THE CASTLE

The Italian painter Giuseppe Arcimboldo lived in Prague, Bohemia (now Czech Republic), four hundred and fifty years ago in the largest castle in Christendom. The best and brightest of minds flocked to the court, including alchemists fruitlessly trying to turn base metal into gold (see Teniers, page 88). Maximilian had an even crazier idea, he wanted to show the world that he was the absolute ruler over humans as well as the elements. Arcimboldo interpreted this belief to create this group of paintings.

CREATING THE SPOOKY HEAD

As preparation for the painting Arcimboldo studied the animals in the Emperor's menagerie at Prague Castle and did lots of drawings. He then mixed powdered minerals or plants with linseed oil to make oil paints. He prepared the painting surface by smoothing the panel and coating it with gesso (chalk plus water) or dark brown paint. He then laid out his design on this surface. The artist applied several layers of paint, one on top of the other. The first layer is thick and opaque (the paint ratio has more pigment than oil) and then each subsequent layer is more transparent (the paint is made up of more oil and less pigment). This is called glazing and makes the colours rich and luminous.

> Try drawing your own 'spooky head' – making it up by combining your favourite objects.

ARCIMBOLDO

Arcimboldo came from Italy where his father had taught him how to paint. He worked at the court in Prague for most of his life. His style of painting is called Mannerism. It developed after the Renaissance. Mannerism is about depicting sophisticated ideas rather than reality.

Some of his other portraits done in this style are made up of sea creatures, books, fruit, flowers and even fire and cannons.

Giuseppe Arcimboldo (Italian, 1526/7–94)
Earth, c.1566
Oil on wood panel, 70 × 48.5cm (27½ × 19in)
Private Collection

 Hendrick Avercamp (Dutch, 1585–1634)
Winter Landscape Near a Village, c.1610–15
Oil on panel
53.3 × 94.5cm (21 × 37in)
Rose-Marie and Eijk van Otterloo Collection

FROZEN

Four hundred years ago the Netherlands was frozen throughout the long winters. This period is known as the 'Little Ice Age'. The Netherlands is also known as the Low Country as it is at or below sea level. Areas below sea level have to be protected by great banks or dykes otherwise they flood. There are many waterways in the Netherlands so in winter you could travel great distances across the ice.

WINTER FUN

The best place to meet your friends is on the river. *Can you see the people strapping the skates on to their feet?* Prop your boots up on the fence while you skate. If your toes turn numb go and warm up in the tents where they'll serve you a hot drink. The people in this picture are doing all kinds of activities. ➲ *How many can you find?*

- Pair skating
- Tobogganing
- Fishing – look for the holes in the ice
- Playing *Kolf* (a precursor of golf)
- Playing with a dog
- Chatting with friends
- Racing to the next village!

What else can you see people doing? The more you look at this painting the more details you can see.

ART DETECTIVES

Can you find the horizon line where the ice meets the sky? Where do you think Avercamp was when he painted this – was he sitting on the bank of the river or in a warm room? We are looking down at the scene – if he had been sketching while perched in one of those gnarly trees he probably would have fallen out. In fact he painted the picture back home in his studio using the sketches that he had made from the side of the riverbank. *Can you find Hendrick Avercamp's initials on a barrel?*

CREATING SPACE

How much space does the sky take up in the picture? Would you agree that it occupies exactly half of the picture?

 Signed with monogram lower centre. HA

How does Avercamp create a sense of distance or 'perspective'? If he were to paint all the people the same size, the picture would be overcrowded and it would seem as if everyone was close-by. So he painted the people and buildings further away much smaller and nearer to the horizon. He also uses less colour. The people blend into the haze and we can see less detail as they are further away.

 The colours also affect how we feel: are they strong? *Do you feel as though you are looking at the scene through a cold mist?*

What time of the day is it? The sun sets around 4:30p.m. in December in the Netherlands. *Do you think the laundry will dry in this cold weather?* Look closely ➲ *Can you see the under-drawing?* In some areas he changed his mind; these changes are called a *pentimenti*.

AVERCAMP

Can you hear the swoosh of skates gliding along the ice? Have you ever felt the squeaky crunch of walking on snow? **Avercamp** may not have heard any of those sounds as he was mute and may have been deaf as well. Instead of telling stories, he painted people. They come from all walks of life and all are having fun during the frozen months. Avercamp was born in Amsterdam. He painted this picture at the start of the seventeenth century. The Dutch provinces were fighting for independence from Spain. They were gaining in trade and military power. In art it was the beginning of a period known as the Golden Age of Dutch Painting.

CONSTRUCTION SITE

This painting depicts the most amazing building site – although you may need a magnifying glass to see the details.

Can you find the grumpy king? Some of the workers are resting near a stream behind the king. Follow the stream to a pool of water. ➲ Find the path leading down to the landing on the right, where horses are waiting to carry red bricks. The harbour is bustling with activity; rafts, small boats and ships are laden with building materials. Cranes and pulleys are used to unload them.

Follow the horse carts up the spiral ramp and around the first three levels. *Why have the workers and their families moved in?* Perhaps it would take them too long to go back to their homes in town every day? Dinner is being cooked on open fires and children are playing. *Can you see a little face gazing out of a window?*

The tower is so tall that its top is above the clouds. *How does that compare to the skyscrapers we have today?*

What is the moral of the story?

ART DETECTIVES

Can you find the artist's signature? Look for a stone with the artist's signature and date: BRUEGEL FE, M.CCCCC.LXIII (Roman numerals for 1563). **Hint:** Look for a hammer and nails that rest on the stone by the bottom edge of the panel.

Can you see someone going to the toilet in plain sight! He is pointing his bare bottom at the monarch! *What do you think the not-very-hidden-message is?*

Can you see the grey under-painting coming through? The paint is almost transparent. Brueghel worked quickly with thin glazes – that is paint with a higher ratio of oil to pigment.

THE STORY

The story of the Tower of Babel comes from the bible's Old Testament. At first all the people spoke a common language and were as one. They came together to build a great tower, reaching for the heavens. When they began to boast about their greatness, the story goes that God confounded them so they were no longer able to understand each other and they scattered all over the earth. In the confusion the Tower of Babel was never finished and remained a ruin.

THE TOWER

The tower is made of different materials held together by cement. The outer shell is made of a pale stone and inside are brick vaults. Brueghel had seen the Colosseum in Rome before he painted the picture. That ancient marvel took about 150 years to build. *Is this structure crumbling like the Colosseum, or is it unfinished?*

FUN FACT

The word 'babel' means a confused noise and originates from this story.

BRUEGHEL

Pieter Brueghel was a highly original painter of the Northern Renaissance (see van Eyck, page 100). His pictures often contain a hidden moral message but they are always full of humour. He painted ordinary people and his nickname was 'Peasant Brueghel'. He lived in the vibrant port city of Antwerp, in present-day Belgium, and his sons became famous painters in their own right.

Signed and dated 1563

Pieter Brueghel the Elder (Flemish, 1525–69)
The Tower of Babel, 1563
Oil on panel
114 × 155cm (45 × 61in)
Kunsthistorisches Museum, Vienna

Jan van Eyck (Flemish, c.1390–1441)

Saint Barbara, 1437
Oil on chalk ground on panel, 31 × 18cm (12 × 7in)
Royal Museum of Fine Arts Antwerp

MEDIEVAL SKYSCRAPER

In this tiny panel van Eyck tells us the story of Saint Barbara. She is shown reading her book and holding a palm leaf. The building site behind her is bustling. ❷ *Can you spot a shed with stonecutters? Can you see three dark windows?* They symbolize the Trinity. In the christian faith this means one God in three persons: the Father, the Son and the Holy Spirit. A man, perhaps a bishop, is showing three women around the construction site. A river, perhaps the Rhine, flows behind the tower. How would you describe Barbara's expression: nervous or calm? *If she were to stand on top of the tower, would her dress reach the ground?*

BARBARA'S STORY

Barbara was born in what is now Syria. Her cruel father locked her up in a tower. He did not want any man to lay eyes upon her and wanted to control his daughter. *Do you think a father can completely control his child?* However, even when she was locked in the tower, he could not control her. While the father was away travelling, Barbara became a Christian. On his return her father was furious and tried to force her to give up her faith. When she refused, he killed her. At that moment lightning struck the murderous father.

Why is her dress so long?

THE PAINTING

The picture is very small, about the size of a standard sheet of paper.

What is unusual about this picture? Do you see much colour? ❷ Find the only area that has some colour.

Some artists prepare their pictures by drawing the outlines of their design on the panel. This is how a picture looks before coloured oil paint is applied. This is the question that has troubled the experts. *Is this painting a study or a finished picture? What is your opinion?*

Should van Eyck have worked more on this piece or does it look perfectly beautiful to you the way it is?

Signed and dated on the original marble frame: IHOES DE EYCK ME FECIT, 1437

FUN FACTS

Some of the tallest buildings in the world:
- Burj Khalifa, Dubai, 828m (2,717ft)
- Freedom Tower, New York, 415m (1,362ft)
- Empire State Building, New York, 381m (1,250ft)
- Eiffel Tower, Paris, 301m (988ft)

MEDIEVAL SKYCRAPERS

Think of the number of workers, the time and the kind of materials involved to build a high rise. Now rewind to 1437 when van Eyck painted this. The featured tower may be based on Cologne cathedral. It took 600 years to be completed (they halted the construction for 400 years). At 157m (515ft) it is still the tallest Roman Catholic cathedral in the world.

VAN EYCK

Jan van Eyck was one of the most influential painters of the early Northern Renaissance and one of the greatest artists in history. He lived in present-day Belgium and, together with his brother Hubert, painted the famous *Ghent Altarpiece*. Many consider it to be one of the cornerstones of Western art. You can study this painting in close up at *http://closertovaneyck. kikirpa.be*.

FREEDOM

This man is called Monsieur Belley. Is he young or middle-aged? *What kind of character do you think he has: proud or modest, foolish or wise?* Do you think he would be easily bullied? *Do you think he has had a hard life or an easy one?* ➡ Look at his hands. *Has he done manual labour?* Notice how the veins in his hands are painted and the similarity with the marble of the pedestal.

SLAVERY

Imagine being born about 270 years ago in Senegal, West Africa. Aged two you are sold as a slave and shipped off to the French colony of Saint-Domingue, (present-day Haiti). There you are one of 500,000 slaves who speak many different African languages. You cannot always understand each other. Dawn to dusk you toil in the sweltering heat working in the coffee and sugar cane plantations. The fruits of your labour are sent back to Europe to be turned into sweets and luxury goods. This was Belley's life.

LIBERTY

Eventually Belley bought his freedom. He fought in a revolution on the island. He then travelled to Paris and represented Saint-Domingue in France. At long last Jean-Baptiste Belley was a free citizen of France.

EQUALITY

Belley is shown leaning against a pedestal holding a marble bust. Guillaume Raynal (1713–96) supported the abolition of slavery. Even though Raynal's head is much larger than Belley's, they are on the same level. However, do you think they are equals?

FRATERNITY

Revolution is raging in Europe. Girodet has been commissioned to paint the achievements of the Revolution. *Does Girodet paint Belley in his studio or on top of the hill?* Is the landscape French or Caribbean? ➡ The smoke from a burning building is a reference to the revolution that Belley fought in.

Belley is gazing at the sky. *Do you feel like tapping Belley on the arm so he will turn around and look at you?* Why is he wearing a shiny gold earring?

Signed and dated lower left:
A L Girodet f.cit an V.

FUN FACTS

- 'An' means 'year' in French
- The Roman numeral V stands for the fifth year in the French Revolutionary Calendar, which is the year 1796 in our Gregorian calendar.
- 'Liberty-Equality-Fraternity' is the motto of both Haiti and France.

In Roman times a freed slave who advanced to the rank of knight was allowed to wear a gold ring and run for public office. The tri-coloured silk sash is tied around the waist of his stylish uniform. *Do you know the three colours of the French flag?*

NAPOLEON

In 1802 Napoleon reinstated slavery. Later that year Belley returned to Saint-Domingue. There he was arrested and brought back to France where he died in prison three years later. In 1848 France once again abolished slavery, this time for good.

ART DETECTIVES

Can you spot the signature and date in the painting? It might not be what you think!

GIRODET-TRIOSON

Anne-Louis Girodet de Roucy-Trioson (a man, despite his first name) was orphaned early and adopted by his guardian M. Trioson. At first he painted in the neo-classical style of his teacher, David, but then became an early Romantic painter. He is sometimes called a 'Romantic Rebel'.

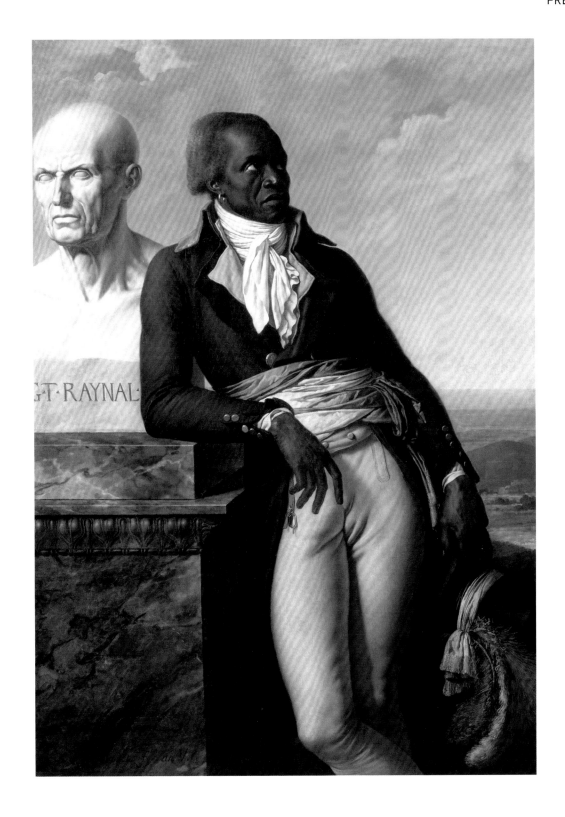

GT·RAYNAL

Anne-Louis Girodet-Trioson (French, 1767–1824)

*Jean-Baptiste Belley, c.*1797
Oil on canvas, 159.5 × 112.8cm (62¾ × 44½in)
Château de Versailles, France

 Winslow Homer (American, 1836–1910)
Dressing for the Carnival, 1877
Oil on canvas, 50.8 × 76.2cm (20 × 30in)
The Metropolitan Museum of Art, New York

INDEPENDENCE DAY

Imagine: it is Independence Day! Time to get ready for the parade. On this 4th of July, 1877 temperatures in Virginia may climb to more than 32°C (90°F) *What time of the day is it?* Everyone is getting ready early in the morning while it is cool.

COSTUMES

Did you make your own costume or is someone sewing you into your outfit? Would you go dressed as a Harlequin? The Harlequin is the clown from the *Commedia dell'Arte*, Italian sixteenth-century theatre. His costume is usually made of red, blue and yellow patches. He sometimes wears a mask and carries a wand. If you want to be the Harlequin your role will be to play tricks on people, especially your master.

What are the colours of the Harlequin's costume?

PARADE

One child is prepared for the heat and is carrying a straw fan. *Do you think they bought that fan or made it themselves?*

The dazzling light is throwing patches of highlights on the group. What does the Harlequin have in his mouth? *Will the woman who is smoking the pipe catch the butterfly?* The woman on the left is sewing a button on the Harlequin's costume. *What is the little girl on the left holding?* Do you think she is standing by herself because she wants to be the first to go to the party?

The children are not wearing shoes, even though there may be snakes in the grass. *Are their clothes new or are they also made of patches and rags?* In 1877 in the southern states African Americans had only been free for twelve years. Many were very poor.

HOLIDAYS

For **Carnival** people dress up in costumes and party. Carnival is still a big festival in many places. **Junkanoo** was celebrated during the times of slavery in the Bahamas before spreading elsewhere including the United States. During Junkanoo people wore masks. **The 4th of July** is the day Americans celebrate independence from Great Britain. *Do you think this picture is a mix of all three celebrations?* Will everyone have a great time? ➲ How many flags can you spot?

IN THE OPEN AIR

En plein air is French for 'in the open air'. Do you think Homer painted this picture *en plein air* with his easel propped up in the fenced-in garden?

HOMER

During the American Civil War (1861–65) <u>Homer</u> worked for a magazine. Homer's illustrations helped show people what was happening in the war. After the war ended and slavery was abolished Homer returned to Virginia to find out how people lived. He originally called this picture: *Sketch – 4th of July in Virginia.*

Homer had been to Paris in 1867 and saw how French artists were painting. He developed his own style of painting

Many think that Homer was the greatest American artist of the nineteenth century. In addition to oil paintings he is known for his watercolours.

Signed lower right:
WINSLOW HOMER
N.A./1877

FIRE!

Imagine: you are standing on the banks of the River Thames next to William Turner, the most famous artist in Britain. Below you, Londoners are huddled together to watch the horrific spectacle before them. The city will never look the same again.

Can you feel the heat emanating from the blaze? Do you feel as if you were really there? ➲ Spot the sparks flying over Westminster Bridge! *Can you see the stars and the moon reflected in the water?* ➲ Look for the towers of the Parliament buildings.

THE CAUSE

Early in the morning on October 16, 1834, workmen had filled the basement furnace of the old Houses of Parliament with too much wood and kindling. The chimney flues had not been cleaned for a long time. The dirty flues overheated and exploded. At 6p.m. a gigantic ball of fire blew through the roof.

Does the sight remind you of a volcano erupting? That night the large medieval complex within the Houses of Lords and Commons burned to the ground. Fortunately everyone had left the buildings so no one was hurt. Westminster Bridge was not destroyed. Big Ben and the Houses of Parliament that we see today date from the nineteenth century and were built after the fire.

THE SCENE

When Turner heard the news, he grabbed his sketchbook and raced to the river.

He was obsessed with the elements and man's inability to control nature. During that October night he saw all four elements come together in one terrifying spectacle. Do you remember the four elements (see page 94)? Turner quickly filled his book with charcoal sketches. Charcoal allows you to be quick; you can erase and blend areas with your fingers.

There are several light sources in the picture, try and identify them.

Would you want to climb on to one of the boats to see the fire from a different vantage point?

THE STUDIO

Back home, Turner began to paint, working from memory and his sketches. *Does he paint sharp contrasts or blend the colours?* His brush is loaded with thick, paste-like paint called impasto. In some areas he applies the paint with his palette knife, the metal tool used for mixing paint. In other places he uses a paintbrush. ➲ See if you can find the different areas.

TURNER

Turner was one of the most important Romantic artists in Britain. His rival was Constable (page 24) Looking at Constable's gentle images of Britain you feel as though you are a part of the landscape. Turner wants you to *feel* the drama of nature. In his other pictures storms rage over the seas and dramatic sunsets illuminate the skies. At the end of Turner's life his pictures become almost abstract. Constable never left Britain. Turner travelled extensively on the Continent. *Do you prefer Constable or Turner, or perhaps you like both?* The two men were never friends.

Turner also made some wonderful watercolours. He was a bit eccentric and saw very few people.

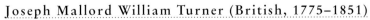

Joseph Mallord William Turner (British, 1775–1851)
The Burning of the Houses of Lords and Commons, c.1834–5
Oil on canvas, 92.1 × 123.2cm (36¼ × 48½in)
The Philadelphia Museum of Art

 Francisco Goya y Lucientes (Spanish, 1746–1828)
The Third of May 1808, 1814–15
Oil on canvas
268 × 347cm (105½ × 136½in)
Museo Nacional del Prado, Madrid

REBELS

This picture is rated **PG-13** so don't look if you think you'll have nightmares. Unlike battle scenes that are shown in films where we know it is all made up what we see here really happened.

This picture is about a real life event.

The painting is set in Madrid, Spain, during the early hours of the 3rd of May 1808; it is still dark outside. A large lantern is placed on the ground to illuminate the area. It is casting eerie shadows. Why does Goya want us to see the faces of the victims and not those of the firing squad? *Do the victims look like soldiers or simple folk?* To decipher this story it helps to have some background.

REVOLT

Napoleon had crowned himself emperor of France in 1804. He wanted to rule all of Europe, including Spain. On the 2nd of May 1808, the Spaniards rose up against Napoleon's occupation. The next morning a French general ordered the execution of the Spanish rebels. This is the subject of this picture.

The events of the early days of May 1808 led to a war that lasted six years. With the help of the British army, Spain defeated Napoleon. Many people on all sides lost their lives.

THE PAINTING

Goya began painting the vast canvas in 1814, the year the war had ended. He had heard the story and he painted what he imagined happened on that spring morning in Madrid. *Is he using many bright colours or are there large areas of muted earth tones?*

Use a tape measure to figure out if the people in the picture are life-size.

The canvas is huge; it is higher than your average living room ceiling and very long. This increases its impact as we feel as if we are actual spectators.

Why do you think *The Third of May* is considered by some to be the first 'modern' painting?

Goya did not paint a traditional battle picture. This is a realistic picture showing the horror of war.

WHAT DO YOU FEEL?

This is a powerful image. Describe your feelings when you look at this picture?

HORROR
FEAR • SHOCK
SURPRISE
COMPASSION

GOYA

Goya was 68 years old, sick and deaf, when he painted this unforgettable masterpiece. Goya had worked for the kings of Spain. This included the period when Napoleon's brother was King of Spain. During the war years Goya created portraits of Spanish and French generals as well as the English Duke of Wellington. Goya also produced a famous series of etchings called *The Disasters of War*. They are powerful protests against war.

INDEX

Impressionist, 25, 36, 39, 84 Impressionism 51, 84 Post-Impressionist 51
Industrial Age 84 revolution 47
Ingres, Jean-Auguste-Dominque 36, **46**–7, 56, 84
Jean-Baptiste Belley **103**
Klimt, Gustav 48–9, 76
La Maestà 76
Lady with an Ermine 18, **19**
landscapes 24–5, 28–9, 90–3, 96–7, 106–7
Landseer, Sir Edwin **16**, 17
Las Meninas 35
Laughing Fisherboy **42**
Laying Down the Law **16**
Leonardo 18–**19**
letters 44, 51, 68–9, **70**–1
Liotard, Jean Etienne 68, **69**
Lord of the Rings 55, 68
Madonna and Child Surrounded by Cherubim and Seraphim **81**
Manet, Edouard 35, 36, 43, 47, 84, **85**
Mannerism 94
Marie Antoinette 32–3, 36
Maximilian II, Holy Roman Emperor 94
Melun Diptych, The **80**
Mistress and Maid **71**
monarchs Charles I, of England 40–1, Charles VII, of France 80, Charlotte, of England 64, Darius, of Persia 55, George IV, of England 31, Henry VIII, of England 44, Louis XIV, of France 67, Louis XV, of France 21, Louis XVI, of France 32, Victoria, of England 17
Monet, Claude 84
Gersaint, Monsieur 66–7
Morocco 56
Munch, Edvard 26, **27**
music 83, 92
mythology 92–3
Napoleon 25, 102, 109
Neo-classical 102
New Testament 76
North Pole 29
Norway 26
Nubian Giraffe, The **31**
oil paints 21, 22, 64, 71, 94, 101
Old Testament 79, 98
Orpheus 92–3
Orpheus Charming the Animals **93**
Oudry, Jean-Baptist **20**–1, 32
palette knife 13, 60, 64, 106
parchment *see* vellum
Parry, William 29
pastels 26–7, 68–9
pentimenti 35, 75, 97
Philosopher's Stone, The 10, 88
photography 36
Picasso, Pablo 56
piglet *see* animals
Place de la Concorde **37**
playing cards 72–5
portraits 10, **19**, **20**, 21, 32, **33**, **34**, 40, **41**, 44, **45**, **46**, 47, 48, **49**, **50**, 51, 60, **61**, 63, 64, 67, 94, **103**, 109
Princess Elizabeth and Princess Anne **40**
Railway, The **85**
Raphael, 64

Realist 13–4, 36, 59, 68, 109
religious 22–3, 76–83, 98–102
Renaissance 94 early 76, 80 Northern 44, 55, 98, 101
Rest on the Flight into Egypt **82**
Reynolds, Sir Joshua 60, **61**, 63
rhinoceros *see* animals
Rococo 67
Romantic, 25, 29, 56, 91, 102, 106
Rothschild, Betty **47** James 47
Rubens, Sir Peter Paul 35, 40, 52, **53**, 56, 64, 79
Rudolf II, Holy Roman Emperor 10
saints Barbara 100 Francis 22 George 52
Saint Barbara **100**
Saint Francis in the Desert **23**
Saint George and the Dragon **53**
science 86–9
Scream, The 26, **27**
Sea of Ice, The **28**
self-portraits **50**–1
Self-portrait with Bandaged Ear and Pipe **50**
seraphim *see* angels
Shop Sign of Gersaint, The **66**
shopping 67
silver leaf 48
Sir John Godsalve 44, **45**
skyscrapers 98, 101
slavery 102, 105
Sleeping Dog **15**
sports 58–9 archery 60, **61** rowing **58**–9 winter **96**–7
tempera 22, 54, 77
Temptation of the Christ on the Mountain, The **77**
Teniers the Younger, David 88, **89**, 94
Third of May 1808, The **108**
Titan's Goblet, The **90**
titans 91
Titian 64
Tower of Babel, The 55, 98, **99**
trains 47, 84–5
Tribuna of the Uffizi, The **65**
Turner, Joseph M.W 25, 29, 91, 106, **107**
Van Dyck, Sir Anthony **40**–1
Van Eyck, Jan 80, 98, **100**–1
Van Gogh, Theo 51
Van Gogh, Vincent **50**–1
Van Rijn, Rembrandt 14, 43, 51, 71, 75, **78**–9
Velázquez, Diego **34**–35, 79, 84
vellum 10–11
Venus of Urbino 64
Vermeer, Johannes 14, 43, **70**–1, 75, 79
Versailles, 20, 32, 103,
Vienna 47–8
Vigée Le Brun, Elisabeth Louise 32, **33**
Watson and the Shark **62**
Watson, Brook 63
Watteau, Antoine **66**, 67
Wild Boar Piglet, A **11**
Winter Landscape near a Village **96**
Woman in Turkish Dress, Seated on a Sofa **69**
Wright of Derby, Joseph **86**–7
Zoffany, Johann 64, **65**
zoos 21, 31, 56

Thanks!

PICTURE CREDITS

THE END